W9-BXB-273

PAINTING YOUR VISION
IN WATERCOLOR

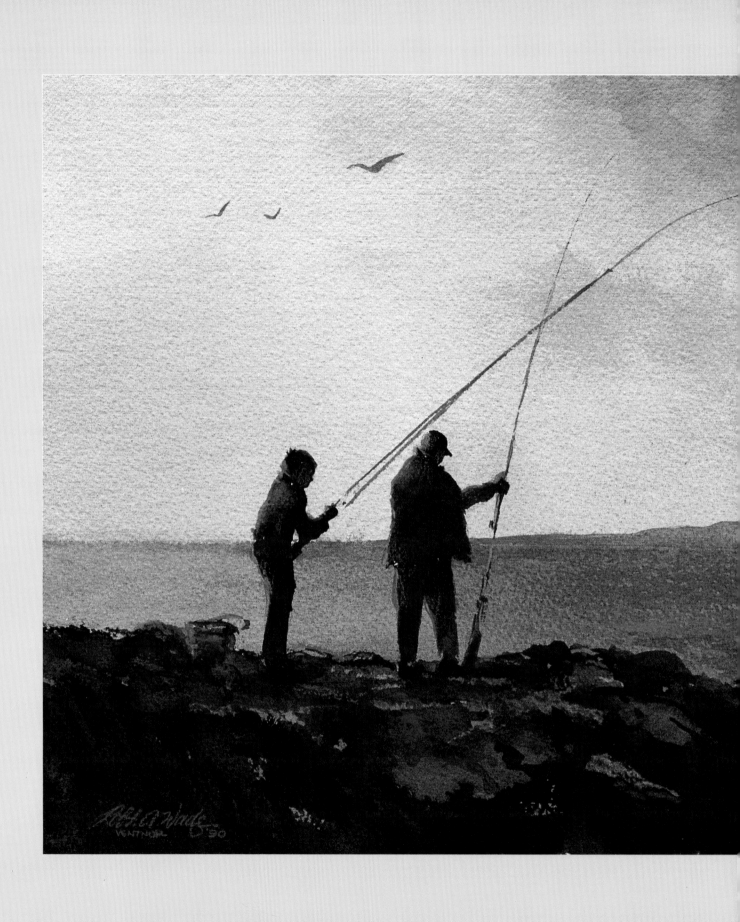

PAINTING YOUR VISION
IN WATERCOLOR

"Lord of beauty, thine the splendor
Shewn in earth and sky and sea,
Burning sun and moonlight tender,
Hill and river, flower and tree:
Lest we fail our praise to render
Touch our eyes that they may see."

Robert Wade

NORTH LIGHT BOOKS

Cincinnati, Ohio

About the Author

Robert Wade has an international reputation as a painter and teacher. This Australian artist's enthusiasm and creative thinking ensure that he is in constant world-wide demand for appearances to teach and demonstrate.

Among his over one hundred awards are seven major awards of New York's famed Salmagundi Club; the Cornellisen Award of the Royal Institute of Painters in Watercolours, London; and three Gold Medals of Camberwell Rotary (Australia).

He is an elected member of the Australian Watercolor Institute; Knicker-bocker Artists, New York; Salmagundi Club, New York; Fellow Royal Society of Arts, London; International Society of Marine Painters (USA); Honorary Member of the Mexican Watercolor Society. Wade is also the author of *Painting More Than the Eye Can See* (North Light Books). He lives near Melbourne, Australia.

Painting Your Vision in Watercolor. Copyright © 1993 by Robert A. Wade. Printed and bound in Hong Kong. All rights reserved. No part of this book may be reproduced in any form or by any electronic or mechanical means including information storage and retrieval systems without permission in writing from the publisher, except by a reviewer, who may quote brief passages in a review. Published by North Light Books, an imprint of F&W Publications, Inc., 1507 Dana Avenue, Cincinnati, Ohio 45207. 1-800-289-0963. First edition.

97 96 95 94 93 5 4 3 2 1

Library of Congress Cataloging in Publication Data

Wade, Robert A.
 Painting your vision in watercolor / Robert A. Wade. — 1st ed.
 p. cm.
 Includes index.
 ISBN 0-89134-462-4
 1. Watercolor painting—Technique. 2. Visual perception.
 I. Title.
ND2420.W3 1992 92-21547
751.42'2—dc20 CIP

Edited by Rachel Wolf
Designed by Clare Finney

Dedication

This book is dedicated to . . .
Ann, my critic, my traveling companion, my partner, my life.
Cameron, Stephanie and Alistair, who bring such joy to their
Nan and me.
Our ever-expanding family, who all support me and encourage
me to keep on painting.
All who love Watercolor—may light and color fill your lives
with joy.

Appreciation

Greg Albert, my editor, for his wise counsel and friendship, and
a million thanks to Rachel Wolf and Kathy Kipp and all the
dedicated people at North Light Books.

Table of Contents

Section II—Let's Get Cracking

Introduction

In his book *Painting as a Pastime*, Sir Winston Churchill wrote: "Happy are the painters, for they shall not be lonely. Light and colour, peace and hope, will keep them company to the end, or almost to the end, of their day."

While visiting London in September 1989, I was privileged to be a guest at the 100th birthday party of the late Roland Batchelor, at that time the oldest living member of the Royal Watercolour Society.

After a most interesting audiovisual retrospective of the artist's life, the grand old man walked the length of the Bankside Gallery unaided and without even a walking stick. He made a very humorous speech, at the end of which—again without assistance—he walked firmly back to his seat, where he set about blowing out one hundred flaming candles on his birthday cake!

Afterward, as he and I were chatting about watercolor, the centenarian turned to me and said, "I say, old chap, just when are you flying home to Australia?" "Tomorrow evening, sir," was my reply. "Oh, what a shame!" he said. "My solo show opens two days from now and I would have so liked you to attend."

What an inspiration he provides—to be painting in our beloved watercolor for the rest of our lives. Maybe the medium breeds longevity. When I recently called on Rowland Hilder in his Blackheath home, he greeted me with a wry smile and said, "Bob, you know I've just turned eighty-six. I suppose that means I will now have to give up all-in wrestling!"

This painting business is seldom smooth; indeed, it's often very rough. I've written this follow-up to my first book, *Painting More Than the Eye Can See*, to explain in greater depth some of my ideas that can assist you in making better paintings. If I can help smooth out some of the hard times you'll experience in your painting, then I will have played a part in making the rest of your life a little happier.

Sharing

When I was about to start writing my first book, a fellow artist said to me, "Robert, you must be a dumb cluck! Why tell them all your secrets?" Well, you know what? I don't have *any* secrets. Sharing my thoughts, my ideas and my solutions to a few knotty problems is greatly rewarding. My readers may learn to surmount obstacles that have impeded their progress for years.

What if the Old Masters had died without passing on their knowledge? In this difficult medium, we need all the help we can get. As for someone copying my way of painting after reading my book, that's a load of rubbish. If I could tell you and show you everything I know, you *still* wouldn't be able to paint exactly as I do.

If I knew the thoughts and painting methods of Sargent, Turner, Winslow Homer—or anyone else for that matter—I could still paint only *in my own personal way*. That's something each of us must realize.

I am encouraged by the fact that so many people have read and benefited from *Painting More Than the Eye Can See*. Those same readers will now benefit from more information about *Visioneering* and *Percep-*

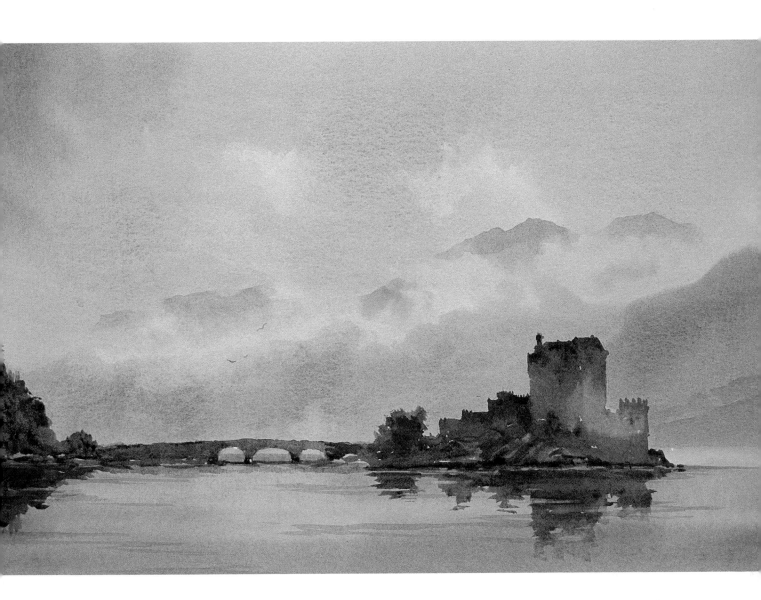

tive Observation, two vital subjects to which they were introduced in that book.

Attitude

An artist friend in Britain wrote to me recently, "I am much enjoying your book, but it really raises as many questions as it answers!" Really, that's my objective in teaching . . . to point the way, to start the investigation and then let the creative spirit seek a solution. In the seeking you are likely to discover far more than you would have imagined possi-

ble. What's more, you will never forget it because it will be your personal solution, one that evolved from your attempts to come to grips with your particular problem.

Does it all sound very serious and academic? Well, don't let it affect you that way. The most important part of painting is having *fun* and the joy of attempting to communicate one's feelings for a subject. *Attitude* has everything to do with painting enjoyment, and with enjoying life in general, too.

Mists on the Loch, 15" × 20"
What if . . . I invented some misty clouds drifting up the Scottish loch behind Eilean Donan Castle? After first wetting the paper where I wanted to place the clouds, I just painted the mountains down into the tops and up into the bottoms of that wet area, then let the water take care of the softness.

A few years ago I took a large group of Australian artists on a painting tour of Switzerland and Italy. One of the "students" was eighty-four years old, and I wondered how he would ever be able to stand the pace. By golly, it was the boot on the other foot: *We* couldn't keep up with *him*! Always whistling and singing, full of the joy of just being alive, he inspired the rest of us. When we would arrive at a new painting site, he'd be first out of the bus, rubbing his hands in anticipation, impatient to get at it.

While some people were still wondering where to start, maybe having a bit of a grizzle about the lousy site I'd selected, Stan would already be at his easel, humming with unrestrained delight, as eager as a child with a new toy.

Life is about positive and negative thinking. Whenever we think we can't do a thing, then there's no way that we can do it. But when we think we *can*, we're setting ourselves up to succeed.

We're lucky to be involved with this wonderful painting experience. Don't let worry or fear about the finished result of the painting rob you of the joy, exhilaration, excitement and anticipation of each moment you spend in its creation. It's the lot of the artist to communicate to those who are blind to it that, despite all of the dreadful happenings, our world is still a very beautiful and wonderful place.

Basically this book is about positive thinking, attitudes, imagination, awareness, search, discovery, and the wonder and joy to be found in the magical medium of watercolor. By applying my painting motto, "What would happen if . . . ?" you'll make a world of options open up to you.

Much of the information presented in this book has evolved from my personal convictions about the importance of developing a *feeling* for a painting, not just *seeing* the subject as it is. My convictions about this have been strengthened by talking and painting with wonderful artists in many different countries. I've been lucky to have had the opportunity to travel widely, and I'm even luckier to have made so many true and sincere friendships on my journeys in the quest for knowledge.

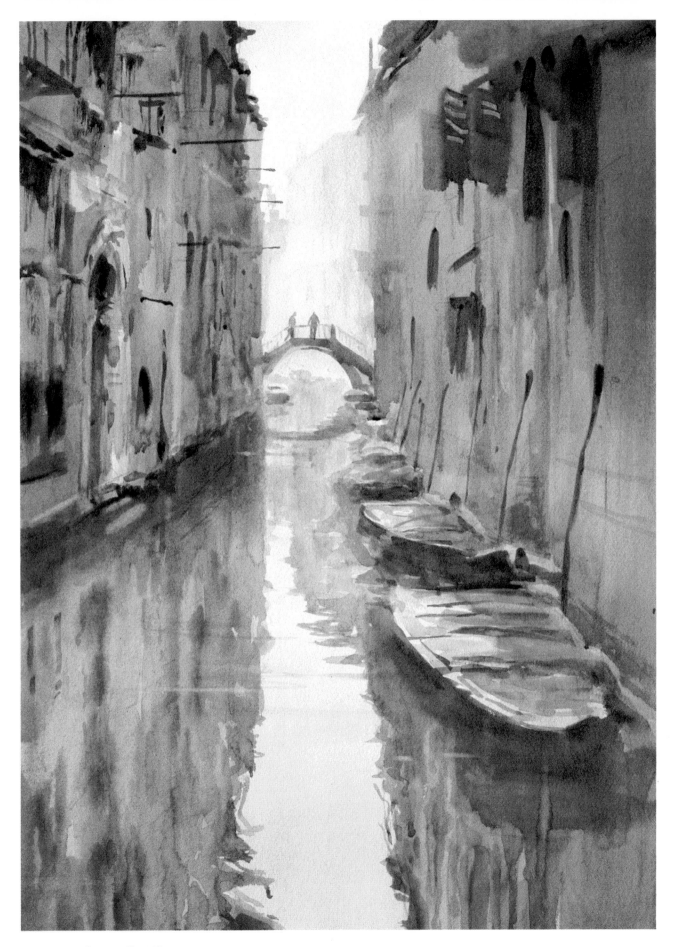

Venetian Glow, 30" × 20"

Section 1
Watercolor
Wade's Way

EXPOSITION

Chapter 1
The Studio, My Workplace

Here's where I really get down to the business of producing major watercolor works for exhibition, the nerve center of the whole operation. Working in the field is the best fun of all, and a necessary part of our painting development. But when things go wrong out there, it's possible to render only minimal first aid to the ailing patient. Back in the studio—your operating theatre—you can launch an "all stops out" effort to restore life to a creation that is rapidly expiring before your very eyes! All is on hand: hair dryer, water spray, adjustable-angle desk, sandpaper, steel wool, gouache, pastel and all the other hundred-and-one lifesaving tools and methods that you can call on to pull that failing job back from a watery grave. Therefore, it is essential to set up your studio or painting place in a manner befitting major surgery, with each piece of equipment in its proper place so you can put your hand on it the moment it's required. There's nothing more frustrating than being unable to grab the very thing you need to save a worrying situation. Frantically you search for it; by the time you

find it, it's too late—the color's dried in the offending area, the wash has run beyond redemption, or your darks have leaked into an early morning sky, and disaster stares you in the face.

Your Own Space

Our studios are very personal places, uniquely suited to our own methods of working. They evolve over many years of gradually adding little extras when they can be afforded, expanding as a grown son or daughter vacates a room. (You're not losing a child, you're gaining a studio!)

Space *is* important. You need room to back off from your painting to squint at it from a distance. You need storage areas for a variety of mats, books, frames and framed works, sketching gear, photographic equipment, props, materials and stock, all of which should be stored on shelves and in cupboards to maintain an atmosphere of tidy professionalism.

Few of us have the chance to plan a studio from scratch. Because we usually work in a restricted area of the home or a small corner of the family room,

it's vital to plan carefully to ensure that every bit of space is utilized to its maximum. However, I believe it's mandatory for us to be able to shut out the family and the outside world at times, to achieve total solitude so we can concentrate completely on our thoughts and reactions to the painting at hand. That's why a studio with a door is ideal; we can retreat behind it and conjure up our own little world.

Set the Mood

My own studio has another very important component: Music. Music has always been an integral part of my life and I consider it essential for my peace of mind while painting. It plays constantly while I work, providing a background of sound to suit the mood I'm trying to inject into my subject. I also record tapes of natural sounds—the gentle sound of raindrops falling on gum leaves in the bush . . . the early morning carols of the magpies and the laughter of kookaburras high in the trees . . . the tinkling gurgles of the water from a spent wave as it runs back over the stones on the sloping beach to join again

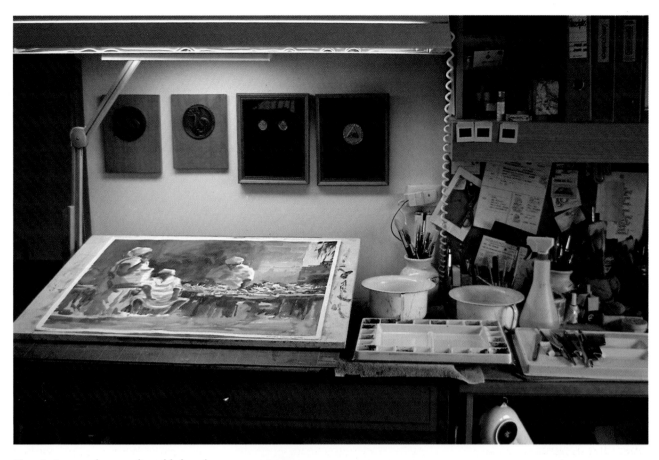

My painting area has an adjustable bench top and a bank of Optima Durolite fluorescents for constant lighting conditions. My water containers are rigid plastic baby's pots (invented to carry water!).

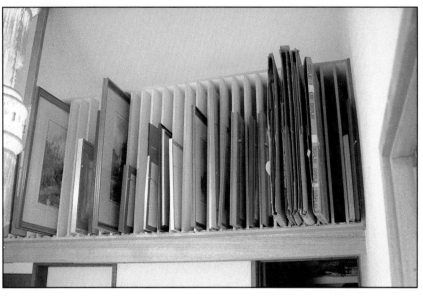

Overhead storage racks for framed works have a base lined with carpet to avoid scratching the frames.

with the next surge of foam. I play these wonderfully evocative sounds to help me recapture the atmosphere of the place where I've sketched or photographed the subject of my next painting. I guess it's a bit like method acting—feel the cold, feel the summer breeze, smell the smoke from the autumn leaves. Although I risk being dubbed a nut, I do find that it helps heighten my sensitivity and awareness in my personal creative process.

Lighting

Good lighting is imperative. I always work under artificial light in my studio; whether I happen to be painting at six in the morning or eleven at night, I always have a constant light source. I use Optima Durolite tubes, which *are* quite expensive but provide a light very close to natural light. If they are out of your price range, use two ordinary fluorescent tubes, but balance their light temperature by having one cool and one warm tube.

Other Paraphernalia

Art books have fascinated me since I was a kid, and I've been collecting them from about the time I was ten, so you can imagine the size of my library, and how much studio wall space it takes to house this collection. I've also been fortunate to meet a number of the authors over the years; so many of these treasured volumes are signed copies with personal messages inscribed in them. I've incorporated the library into the "business space" of my studio setup.

My "work area" consists of storage space for papers, a stock of tube colors, brushes, pens and pencils, spare sketchbooks and other paraphernalia plus my actual painting desk with an adjustable top.

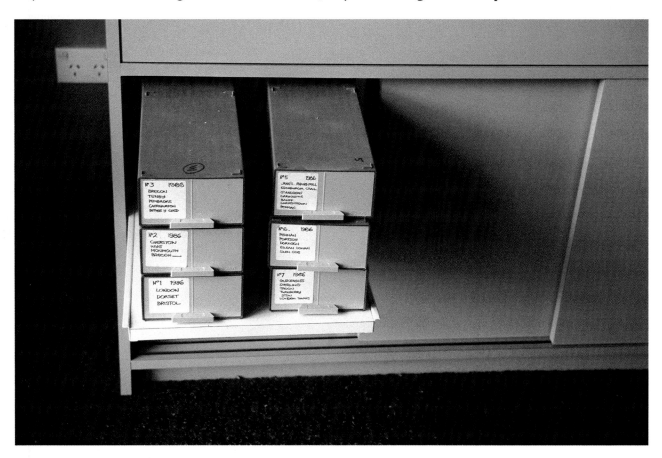

With thirty-five thousand slides in my collection, cataloging and storage must be very methodical; otherwise, chaos would prevail.

The total area is about seven hundred square feet, which I find quite adequate, although I think that if I had ten times the space I would still use it! It all adds up to being *my own place*, an atmosphere in which I feel completely comfortable, at peace with myself and the world. It provides an environment conducive to producing work to the best of my ability. Careful planning of *your* work area will bring its own rewards.

Be Professional

I work on a daily schedule as if I were employed by somebody else, starting work at eight, quitting for lunch at noon, resuming at one and then working until I finish the task I have set for myself that day. But I never forget how fortunate I am: I'm doing something I love and getting paid for it!

My bookwork is businesslike, too. I attend to my paperwork regularly. Art show entry deadlines, gallery schedules, workshops and demonstration appointments are all entered in my studio diary so that no date can be overlooked. I also keep a log book in which every painting is entered in the following fashion: *91/7-106, The Blue Roof, 15" × 20", Arches Rough, 300-lb.* This code means that it was painted in the seventh month of 1991; it's the 106th painting of the year; it has these dimensions and was painted on this type of paper. The code is also written on the margin of the painting, which will serve as identification in later years when it may be noted by a framer or historian.

The cupboards have drawers for finished unframed works, and underneath are sliding shelves for magazines of 35mm slides. There's plenty of space for my library of art books, too.

Chapter 2
On-Site Painting

Perhaps I've put the cart before the horse by discussing the studio before I talk about on-site painting. On-site painting is extremely important in your development as an artist. A great deal of studio painting time is pretty serious stuff, but on-site work is simply a joy. Sketching on location is one of the greatest pleasures I know, particularly if the experience is shared with a companion or two. It's not necessary to work side by side; within earshot of each other is fine. For me, that is one of the bonuses of teaching workshops: It forces me to leave my solitary studio and return to the great outdoors.

I remember one occasion a couple of years ago, after I had been teaching a great group up at Port Clyde, Maine. There were some fine painters in the bunch and they really kept me on my toes all week. At the end of the workshop, I sketched for several days over on Monhegan Island by myself, then went on to Boothbay and spent some memorable days with Carlton and Joan Plummer as a guest in their delightful cliff-top home at the ocean's edge. Carlton, a member of the

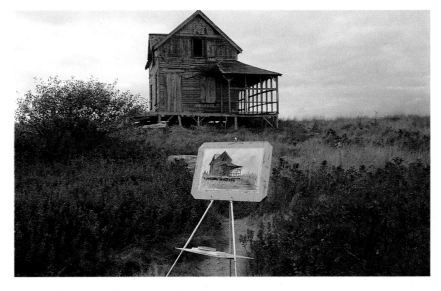

Deserted house on Damariscove Island, Maine.

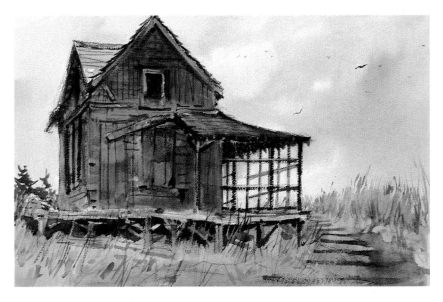

The Derelict, 15" × 20"
Compare this painting with the subject in the photo and you'll see I've painted the *feel* of it.

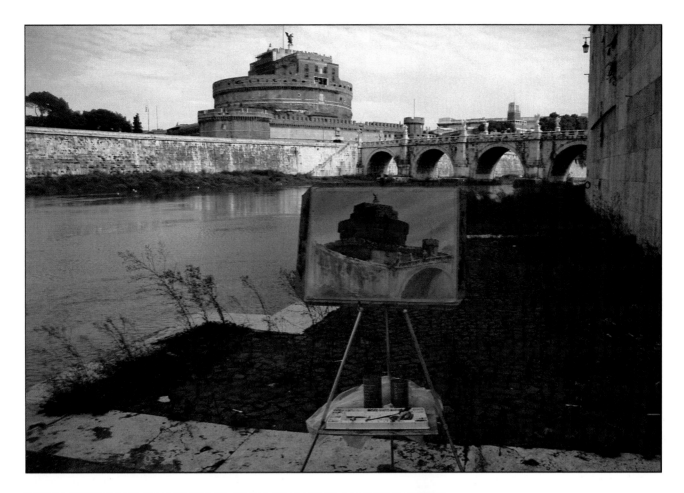

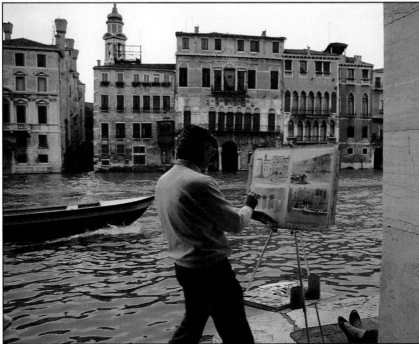

Castel San Angelo, on the banks of the Tiber in Rome, was the subject of a class demo.

This was a class demo from the Fish Market in Venice. I used the divided sheet to paint four subjects from the same spot.

Class demo, Port Clyde, Maine.

American Watercolor Society, is a wonderful painter of the rocks and ledges of the picturesque Maine coastline.

After the bustle and excitement of the workshop, I needed some quiet time. Carlton took me in his boat for a day's sketching to a deserted little place called Damariscove Island. We were the sole inhabitants and at once got to work, setting up about 150 yards from each other. This was just within earshot, and occasionally one of us would call out something like "How's it going?" or "Isn't this great?"

When the light started to run out, we packed up, viewed each other's efforts and headed for home. It was a memorable day, made more so by the company of

a fellow artist and friend. We weren't painting in each other's pockets, just enjoying our work and sharing the experience of nature and watercolor with each other.

I believe it's absolutely essential for you to work in the great outdoors, to develop an appreciation of its wonder and majesty, if you want to portray it in your paintings.

On-Location Gear

Don't take the kitchen sink with you, leave your transistor radio at home, and don't burden yourself with so much equipment that you'd qualify as anchor man for the chain gang! I've seen many students who were absolutely worn out by the time they arrived

at the painting site; they usually brought all the wrong kind of gear anyhow.

Sort out which basics you will really need (and only *you* can determine your own requirements). Write them down and keep the list in your backpack or painting bag. I still refer to my checklist every time I'm packing the kit to set out for a day's painting, so nothing is forgotten.

My own basics are: paper (cut to my required size), palette, brushes, pencils, folding easel, pocket knife, masking tape for fixing paper to my drawing board, tissues, eraser, water bottle and two containers — one for clean mixing water, one for brush washing. That's my basic painting kit.

Accessories should include sunscreen, insect repellent, hat, towel, camera and spare rolls of film. I always carry waterproof golf gear, pants and jacket, to keep me warm in a cold wind. If it's so cold I need gloves as well, then that's a day I wouldn't venture out of the studio.

All the items fit into my wonderful duffle bag, which I haggled over and purchased in Morocco. The bag slings over my shoulder, board and paper fit into a battered old folio, and that leaves me with one free hand and very little weight.

After a day's painting, I put my palette into a strong plastic bag and try to carry it home in a horizontal position to keep soft wet pigments from leaking into

adjoining wells. This plastic bag is a *must* if you are traveling overseas and have to pack your palette in your suitcase. Believe me, it's a disaster to unpack and find that you have alizarin crimson in your underwear and cadmium yellow in your socks!

I've yet to find a completely successful solution to the problem of "end-of-the-day-palette." I prefer fresh-squeezed tube colors to solid color in pans, as they allow me to pick up heaps of pigment on my brush, but this does present a problem in transporting the materials from the painting site. It's a case of "win some, lose some," and if that's my only problem, then things are really good.

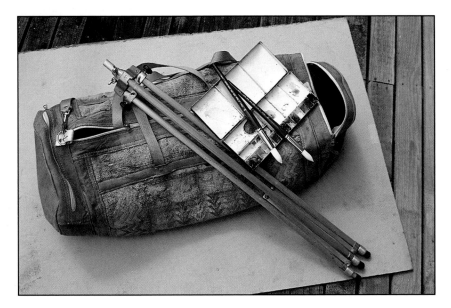

Here is my faithful painting bag—a very experienced world traveler.

Chapter 3
Creative Decisions . . . Wade's Way

Do you . . .

- *Do you want to paint more than simply a report of the subject exactly as it appears before your eyes?*

- *In designing your composition, do you delete or reposition objects in your chosen subject area to make a more interesting arrangement of shapes?*

- *Do you change values to arrive at a better or stronger value pattern?*

- *Do you use color to create your own mood and atmosphere?*

If not, why not?

Do you consider all these factors thoughtfully *before* tackling the job, or does your creative process lie dormant and only occasionally switch on when the painting is already half finished?

Of course, as a painting evolves, all manner of possible changes will suggest themselves to you, but first of all the *major idea* should be decided upon and firmed up in your mind. Only then can you attack the watercolor with a battle plan resolved in your mind's eye, giving you a clear understanding of your objectives. Then you can make on-the-spot decisions to change directions if the painting so dictates, because *you know where you are going.*

My Creative Process
These are the questions I ask myself after I have decided on a particular subject for a watercolor. I'll go into more detail in the next chapter when I talk about *Perceptive Observation.*

1. How does the subject affect me emotionally? Am I excited, disturbed, saddened, soothed, shocked, aroused or mystified, or is there a feeling I just can't describe? If it's the latter, then this could be that extra-special once-in-a-lifetime subject I've been hoping to find.

2. How does it affect me visually? Am I attracted to it because of strong light contrasts, subdued tonal values and their relationships, interesting patterns of shapes, strong abstract qualities or unusual color arrangements?

3. How can I best produce a painting to communicate my feelings for the subject to the viewer? Do I need to inject an air of mystery, drama or romance? Could I possibly change the season or the time of day, turn on the sun or bring on the rain?

4. How will I treat the edges of my shapes? Predominantly soft as in a misty romantic mood? Predominantly hard, as in a dramatic silhouette? Dry-brush edges for a vigorous dynamic approach? Maybe a mixture of two approaches, possibly all three? Which, then, will be dominant?

5. How inventive can I be? Just how far can I take it? The subject before me is only the thought starter. I am the creator, the artist, the author, the poet, the composer. I may breathe life into this subject to give it a presence that nobody else has ever expressed. It may not be such a great subject right now, but by the time I have given it my personal interpretation, it just may become something memorable.

I'm not thinking of the painting as a potential award winner or of pleasing a particular judge.

Photo of Staithes, North Yorkshire, England.

Evening Stroll, 10″ × 14″
What if . . . I were to change this setting to night? Perhaps I could have a few guys chatting outside the pub and an elderly couple walking up the road, to add a bit of interest.

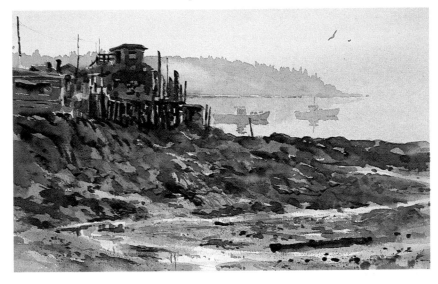

Maine Coast Mist, 15″ × 20″
What if . . . I changed the whole feeling of the sunny day shot, because I'm sure that this area looks misty most of the time. That's how I saw it in my mind's eye and the result makes me feel that I want to draw my coat a bit tighter.

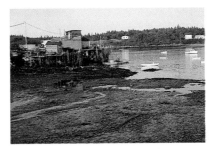

Photo of Port Clyde, Maine.

I'm thinking of my own pleasure and joy, and the sense of achievement I'll derive if I can transform the humdrum into the magical and communicate this to another person. The sale of the finished painting is inconsequential to me and is never considered at this or at any other stage.

After due consideration of these factors, I have a very clear plan in mind and know exactly what I'll be aiming for when I begin the painting session.

Format

There are still other important decisions to be made before commencing the actual painting. These concern the physical properties of the watercolor.

What size shall I make it? Full sheet, half sheet, quarter sheet? There are a number of fac-tors to influence my decision, and these raise even more questions:

How can I best present this image I have formed in my mind? Will a small quarter sheet be too limiting and prevent me from do-ing justice to the image? On the other hand, will a full sheet be too large and tempt me to over-work and to include too much detail? Perhaps it would allow me more scope, a chance to use big-ger brushes for bold shapes and to be more innovative. In fact, the half sheet might be the happy medium, providing the best of both worlds.

Even then the ultimate choice may be decided by a to-tally different consideration . . . for instance, a particular size may be needed to give balance to a solo show.

Should the format be horizontal or vertical? Actu-ally, the question we have just asked ourselves about size—how can I best present this image?— can also be asked about format. We are simply trying to deter-mine the best way of composing the subject. A rule of thumb could be: Vertical subjects (masts, buildings, some figures and so on) are best suited to ver-tical formats, and horizontal sub-jects (landscapes, seascapes and the like) are best suited to more horizontal proportions.

Paper

Now that the format has been de-cided, the next consideration must be the type of paper most suitable for the subject—rough, cold press, or hot press. Each one has quite different character-

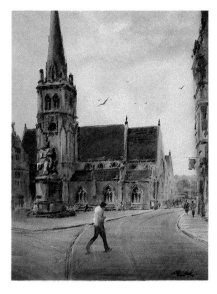

Grey Day, Durham, 20" × 15"
The vertical format seems to be necessary because of the tall spire. Also there's quite a dominance of vertical shapes throughout the subject.

What if . . . we cut off the spire at the clock and made it a horizontal format? The center of interest now comes down into the square. This picture probably works just as well as the vertical format.

Cottage, Millthorpe, New South Wales, Australia, 10" × 14"
The horizontal format is a traditional way of treating this sort of subject and it makes quite a pleasing arrangement.

How about a vertical format for the cottage? It's okay, I guess, but it needs some verticals, so I'll just pop in a couple of golden poplars. Are you beginning to understand the reasoning?

istics, and the nature of your subject will dictate the surface choice.

If the painting is to contain a number of textural areas, a *rough* surface will be most sympathetic to your brushwork. Landscapes with a variety of foliage, old walls, seascapes, and coastal subjects with rocks and surf are typical examples of the subjects suitable for rough.

Cold press (also called *Not*) will help you paint subtle gradations more easily. Quiet water and reflections, architectural details, sky and cloud studies, boats and wharf areas, portraits and figure studies are all ideal subjects for this surface.

Hot press gives quite a different effect. Its extremely smooth surface allows colors to stay on the surface much longer. This encourages them to mix and merge and to settle with something of a globular effect that can be very attractive. I occasionally use it for portrait and flower studies, pencil and wash, or pen and wash.

Which brand? may be your next question. Personally, I keep a large stock of various brands: Arches, Lana, Waterford, Winsor & Newton, Fabriano, and Bockingford, in both rough and cold press, moving from one to another depending on the result I'm trying to achieve. Experience will help you make your choice, as each brand behaves quite differently from the others.

There is still another choice to be considered . . . a tinted paper may be of enormous assistance in expressing mood. Some of the Canson and Ingres papers are suited to watercolor and should not be overlooked.

Don't become "locked in" to any one paper, as this could encourage "recipe painting" because you are so comfortable with it. I always enjoy the challenge of an unfamiliar surface. This is part of the grand adventure, the excitement and fun in every new painting experiment.

Venetian Steps, 15″ × 20″

Rough. I dragged the brush on its side to get that "hit and miss" effect. Fabriano rough allowed me to create many interesting textures yet was very supportive of the picture's mood. This Italian paper is the roughest surface I ever use.

The Santa Maria, 11" × 14"

Cold press. My initial action was to glaze a pale wash of aureolin, rose madder genuine and cobalt blue over the entire surface. See how it all glows? The cold press Winsor & Newton paper encourages washes to flow out very smoothly and evenly as you can see in the sky.

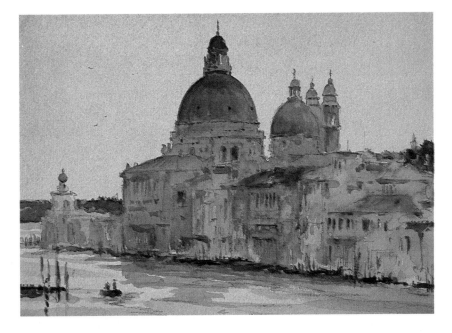

The Chicken Vendor, Fez, 9" × 7"

Hot press. Crescent hot press, with its rather slick surface, keeps color wet for longer periods, as the sizing prevents the pigment from settling down into the paper.

The paint tends to dry in globules, giving it a different quality to the usual smooth, flowed-out finish achieved on other surfaces.

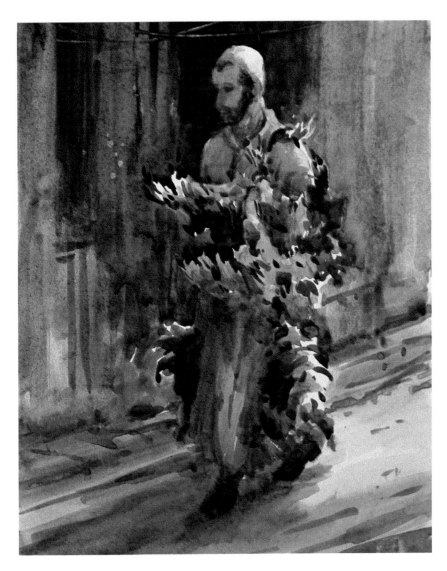

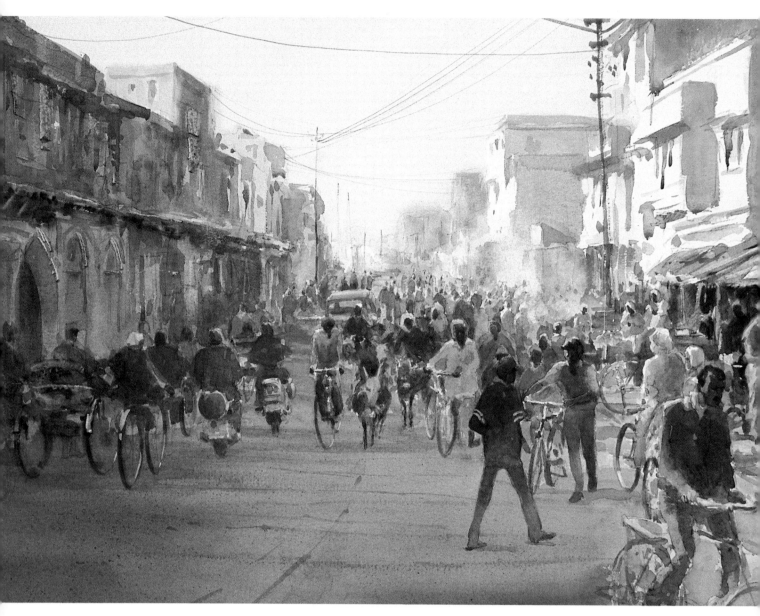

Market Traffic, Agra, 20" × 30"

Cold press. There were many subtle colors in shadows and reflected lights in this bustling market area. Cold-press Lanaquarelle kept me in control, enabling me to keep the color glowing in the areas that would be glazed over two to three times.

Your Particular Vision

These suggestions having been made—and I emphasize "suggestions" as I do not believe in rules—I'm now going to tell you that it is *perfectly legitimate to paint any subject on any surface*. It is your choice. The way you decide to go will be part of the very personal process of producing a painting with *your particular vision*.

Many painters stifle their originality simply because they are too timid to tackle something outside their normal range of subject matter. The dreadful fear of failure is so strong in their minds that they cannot bring themselves to attempt anything beyond the "safe" area in which they have been bogged down.

Well, the good news for the fainthearted is that if you stick to your safe accustomed watercolors, then you are not going to have too many total flops; the bad news is that you *may never*

Detail. See how the shadows sing? Look at all the color changes within the values. Now who said shadows are gray?

paint a winner.

Our moods and personalities come out in our work. I give top marks for originality and courage, and these qualities are far more important than technical facility in my judgment. They will always produce work of character and feeling, whereas timidity and taking the safe road will always result in ho-hum paintings.

The big decision is yours. Which way do you want to go — to stay in your own little neck of the woods, or to take that big step up the ladder? If it's to be the big step, then let me help you. Let me show you "Wade's Way"!

Wade's Way

The major premise of Wade's Way is this:

Never be afraid to gamble and possibly lose a painting. The gamble may just pay off handsomely, and an apparently ordinary picture may suddenly become a great painting. When I am faced with the alternative of creating a complete disaster or a rather average painting, I choose to gamble every time.

At the end of the day, the painting over which we have worried and fretted is very precious to us because of the many hours spent producing it. However, next week it will be history, just another exercise in our lifetime development as painters.

When a painting fails, I feel two different emotions. First, I feel a deep sense of personal loss because I wasn't skillful enough to pull off the concept I had envisaged. Second, I feel a sense of satisfaction because I had the courage of my convictions and I tried.

Some Common Errors

The most common failing I see in every group I teach — and it's the same anywhere in the world — is the miserly way in which many students work. *Too small* sums it up.

• *Thinking small.* Not seeing further than one's nose and merely attempting to record the view just as it appears, as a camera would see it; showing no reaction to the subject, no feeling for atmosphere, no initiative in seeing beyond the immediate visual impression, only an urge to paint it right away with little thought and no expression of personal interpretation. That, my friend, is thinking *small*!

The subject before you is no more than a thought prompter. It should present you with a whole range of options, suggesting many different interpretations and directions for you to make your own personal statement about your feelings for the subject. *That's* what makes a good painting. It doesn't have to look like the subject, it just has to feel like it.

• *Small deposits of color.*

Many palettes are set out with tiny little daubs of color no bigger than a gnat's nut! There's no way to pick up the decent brushload of color so essential for making bold, decisive strokes on your work. Don't worry about wasting your watercolor pigment. Even when it's dried out on your palette it only needs a squirt of water from your spray bottle or atomizer and it will soon become soft and pliable once more.

Squeeze out a decent amount of color and give yourself a chance. I almost fill a well on my palette with a big 14 ml tube; then I can dig into it with a 1½-inch flat brush or pick up a whole bunch of color when I need it.

• **Small brushes.** This tendency goes hand in hand with small color deposits—the one encouraging the other, I guess. Always use the largest brush you can to do the job. Small brushes prompt small strokes, niggled and stippled over, with nasty little results.

In most of my work, about 95 percent of each painting is done with a 1½-inch flat, a no. 14 or a large round no. 36. The smaller brushes come into play only for adding the final 5 percent, the finishing touches of detail or calligraphy.

• **Small areas.** Small thinking, small color, small brushes plus concentration on *small* areas of your painting—they all work against you and your chances of pulling off a beauty. You must maintain a general

view of your painting, keeping it going as an overall unit. Don't get bogged down in one little unimportant spot. The *big* thought must always be uppermost in your mind.

Work the big shapes until there's nothing more you can do with them. Only then should you start to get into those smaller shapes. This will help you maintain continuity throughout the work and avoid a possible conflict of interest, particularly if you have been having trouble emphasizing your focal point.

So, start thinking *big* if you want to get big satisfaction and big results from your watercolors.

Failing to Plan

Here's another very common problem. You've decided on your subject, so you begin to draw it up. That derelict old barn is such a wonderful shape, and you become so absorbed in your drawing that you suddenly find . . . oops! There's no room to fit it all on the sheet. You would really like to attach another six inches to your paper so you can accommodate the structure. Short of continuing to draw right over on the back, you are really in duck soup.

But help is at hand. All you need to do is to use the "ghost sketch." Before you ever make a mark with your pencil, do an invisible drawing using the nail of your little finger as you would a pencil. This will clarify in your

mind just how and where all the shapes will fit. This will also help you eliminate the opposite problem of drawing the barn too small and tucking the whole darned thing into a corner.

If you are still mystified, even with the assistance of the ghost sketch, then here's another handy little hint. Do you remember those old "join the dots" puzzles? We would join the numbered dots and much to our delight an elephant or a donkey would appear on the paper. You can use an updated adaptation of this method to assist you in composing your subject on the sheet. Just begin with the ghost sketch again, but when your finger reaches the spot where, say, a barn roof begins, mark it with a dot. Each time you arrive at a junction or a change in direction, just plonk down another dot. Finally, when you are quite happy with the shapes you have indicated, you have only to draw lines to connect the dots, and "dot's" pretty easy! There's your barn, drawn in the exact position you wanted it.

Limp Paper

Let's take a look at yet another common error. Quite often I see students at work, sitting with a limp piece of lightweight watercolor paper draped over both knees. The wash is dripping from all edges and water is running every which way, completely out of control. When the artist reaches forward to charge a brush, all the

washes change direction and the problem is compounded.

As you know by now, I don't have rules, but this is as close as I can come to having one. It is absolutely *imperative* to have lightweight paper stretched. If it's 300 lb., you must securely tape it down all around the four sides onto a drawing board, which can be of any suitable material. In my studio I use ⅝-inch marine-grade plywood; in the field I use a piece of ⅛-inch compressed fiberboard. Plexiglas, styrene foamboard, lightweight plywood or any similar rigid material could also be used for a drawing board. Work with the top back edge raised at an angle of at least 15 degrees (the angle depends entirely on what suits you) to ensure that the wash must fall towards the bottom of the sheet. This is one of the few means of control over the whims of this medium; why not take advantage of it?

Now that we've solved some of the technical difficulties, let's go on to some ideas closer to the heart of painting.

Remember the old dot puzzles?

Just join the dots and see what happens.

Chapter 4
Perceptive Observation

Perceptive Observation is "Seeing with your brain, Feeling with your eyes, Interpreting with your heart."

My main concern in painting the sort of subjects that I do is the expression of an emotion through light, form and movement (or rhythm). Light and form will be present in every single subject, but the movement may not always be obvious. To be able to translate these feelings from reality to my paper, it is essential for me to observe my subject with much more intensity than the casual viewer would do. I call my way of seeing "Perceptive Observation," which I define as *"Seeing with your brain, Feeling with your eyes, Interpreting with your heart."* It is an artist's way of applying thought and sensitivity to a subject that is in immediate view, to allow a personal representation of what might otherwise be a quite mundane and unemotional rendering.

The last thing I want to do is

Thimi, Nepal, 20" × 30"
Perceptive Observation transforms a dirty, dingy alleyway in Nepal into something rather special. Using the light area like a theatrical spotlight, I was able to radiate reflected light from all around the sunlit source, which gradually becomes darker and cooler the farther from that source we go. The dark silhouette of the Nepalese porter gives tremendous recession and pushes the eye way off down the other side of the sunny square. In the foreground there was quite a deal of glazing, cool over warm, so that the underpainting would produce that lovely glow.

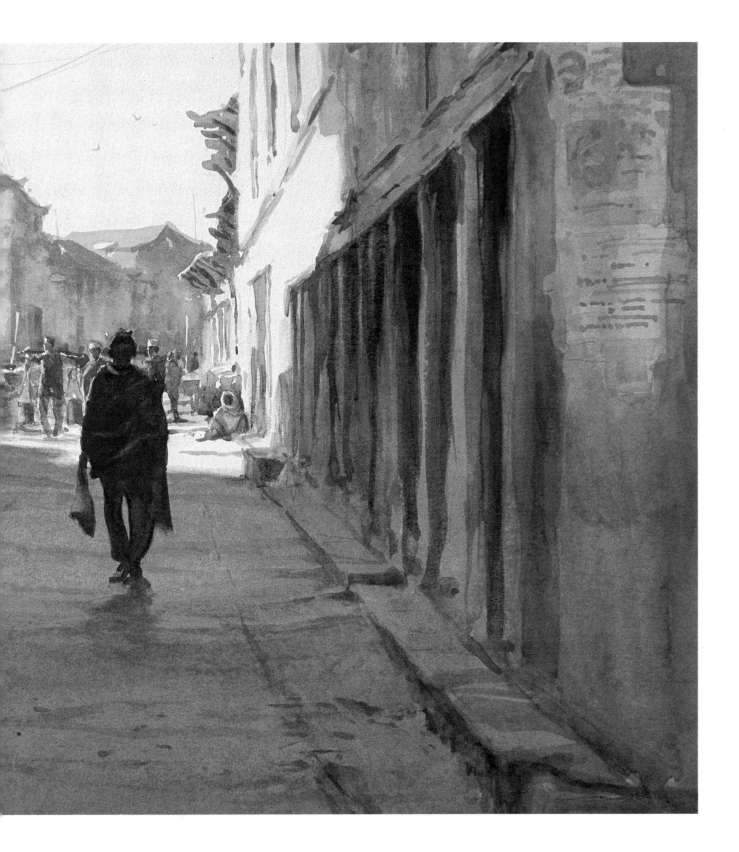

The Priests, Jerusalem, 14" × 10"
Can you feel the billowing of those voluminous robes? Perceptive Observation allowed me to convey that flowing movement. Note the joined shapes.

to make this sound like a cold, calculated, analytical process. It's quite the reverse, in fact. There is no orderly checklist to be ticked off as one goes through the categories. On the contrary, this is an *emotional involvement*, and when combined with *Visioneering* (see Chapter 5), it's a process of becoming at one with the subject, arriving at a *feeling* rather than a result.

This is where the very soul of a painting is born and becomes apparent to its creator, long before a pencil or brush is ever put to paper. It's a consciousness that slowly grows with the artist as he or she delves beneath the surface, feels the mood, selectively disposes of areas that are incompatible with the mood that is materializing, and finally settles on an interpretation and an understanding of the subject that has evolved from this soul-searching examination.

Perceptive Observation will ultimately help to determine the direction the painting will take—it's the fermentation of an *idea*. Ideally the vision will be bigger than the painting, which will allow the artist to reach out beyond the range of his or her normal ability and continue to grow.

Be Visually Aware

Now let us consider the process in a little more depth. I believe that Perceptive Observation is what really sets one artist apart from the throng. As artists we must constantly train our minds

San Gimignano Steps, 11" × 14"
There's a real sparkle in this subject
which could have been very ordinary
without Perceptive Observation to take
note of the light passage across the
forms and to see all the color in the back-
ground.

The painting won the Ogden Pleiss-
ner Memorial Award of the Salmagundi
Club. As I had the honor of meeting this
wonderful painter many years ago and
admired his work enormously, this
award holds special significance for me.

The Arab, 10" × 6"
Again, it's the observation of light and its
effect that makes this little sketch work.

The Doorway, Captain Cook's Cottage, 12″ × 9″
A sketch that is all about light and its movement around forms. The brilliant warm glow is accentuated by placing the darkest darks right alongside the lights.

On the Canal, Chioggia, 15″ × 20″
I thought I'd made a reasonable job of this one, photographed it, and then took it (unframed) to my London gallery. The director looked at it for a minute and said, "No, sorry, we can't hang it! There's a boat just near the bridge and that mast couldn't possibly pass under it."

He was correct, of course. So I borrowed a little brush, extended that line right down to the foreground boat by wetting it, wiping out with a tissue and simply making it another mooring post, which looked great. It went into the show.

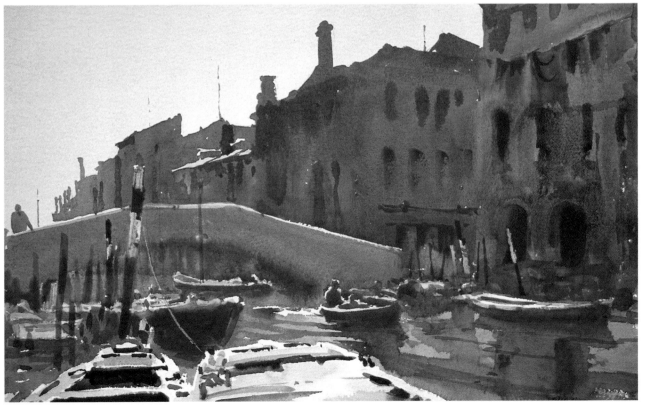

to be *visually aware*. In fact, many people around us are not visually aware. They are vaguely conscious of their surroundings but only as a background to their daily routines. The constant stress of day-to-day living produces so many pressures that a routine sets in: get up, go to work, go to bed, get up, and on and on.

A walk to the railway station, a drive into the city, a trip on the bus, all become quite automatic, all thoughts centering on work, family, or financial problems. The superb morning light, the new leaves and flowers of spring or, for that matter, any other thing of beauty may go totally unobserved.

I believe that it is incumbent on us, the visually aware, to help others appreciate and see the beauty that surrounds us wherever we are. Even in an office or store, a shaft of light falling on a typewriter could make a pattern of light and shade so wondrous it would take one's breath away. A wet wintry day brings remarks about how miserable everything looks and hopes for tomorrow's weather to improve, yet to the visually aware it means something quite different. Winter is a beautiful season, a time when the landscape is having its face washed by Mother Nature . . . gentle rain softens harsh outlines, disguises otherwise ugly shapes and structures, and brings beauty to squalid and unattractive areas. Can't you just see those puddles and reflections?

Having noted all these wonderful sights and effects, the next step is to get right down to work. The first thing to do is *"See with your brain"*: Observe the highlights, the shadows, the values, and their effect on the overall picture pattern plus their color relationships to one another in the general scheme of things.

Next comes *"Feel with your eyes"*: the investigation of shapes and their form, feeling the bulk, the weight, the rhythm, the movement, discovering the receding or advancing of the various elements, observing the textures of edges throughout the subject, and becoming totally aware of your game plan, how you intend to tackle the subject in paint.

By this time all the information has been fed into your mental computer, which will allow you to *"Interpret with your heart."* You can now make this assessment of the mood and atmosphere so that you will be able to paint the *feel* of your selected subject.

I find it difficult to tell where Perceptive Observation stops and Visioneering begins. Hand in hand, they form the "thinking" part of the operation and this is the real basis for painting your vision in watercolor. In the next chapter, we'll go on and talk about Visioneering.

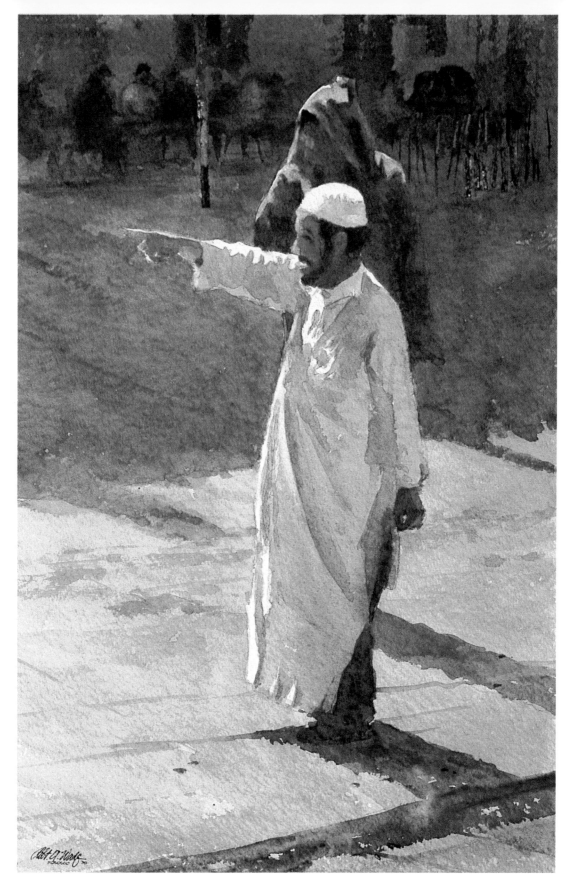

That Way to the Souk, 20" × 15"
Another case of glazing cool over warm to create a tremendous color vibration. Aureolin and rose madder genuine went over the whole painting except for the highlights reserved on the foreground figure. Cool washes were then applied over that warm wash, and you can see the effect it gave. The figures I invented in the background cafe give a good impression of depth.

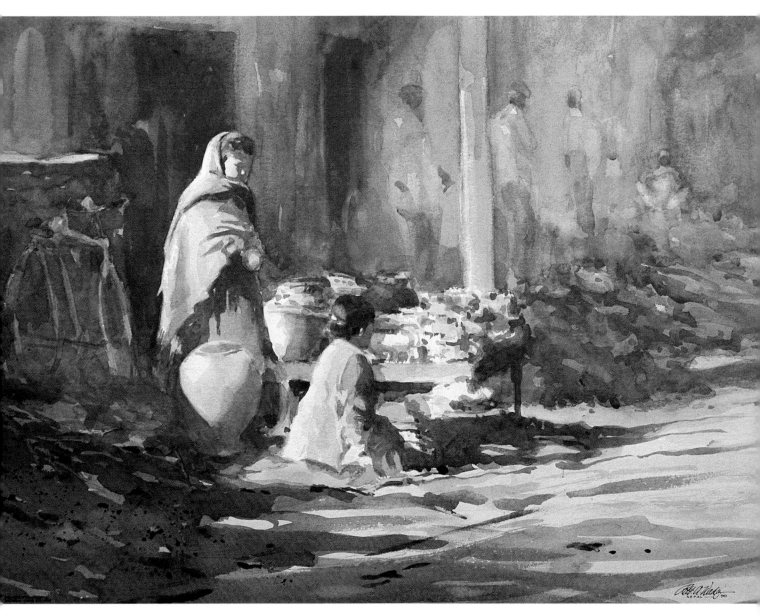

The Potter's Stand, Kathmandu, 14″ × 20″
This class demonstration was to help clarify the importance of light passage through
a painting. Perceptive Observation noted its path very carefully, seeing where it fell
across forms, how the rounded pots and figures caught it, held it, then turned away
from it.

Perceptive Observation . . . Step by Step

Step One

A minimal drawing merely indicated the outlines of the shapes. My main concern was to try to capture the brilliance of the early evening sun behind scattered clouds. I started by laying down a wash of cobalt blue, brown madder alizarin and aureolin over the whole sheet, wiping color away from the sun's area with a tissue while the painting was quite wet.

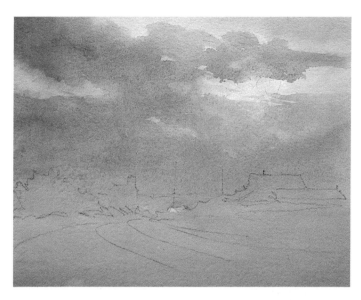

Step Two

After waiting until the first wash was absolutely dry, I misted a film of clear water right over the surface of the sheet. I blotted off the excess water, then painted the darker clouds, mainly wet-in-wet, with mixes of cobalt blue and brown madder alizarin, varying the proportions as I went along, still wiping or lifting with my tissue where I wanted to keep that light.

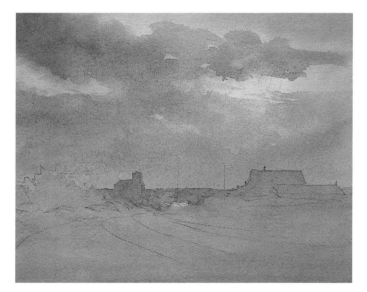

Step Three

The sky was looking just great, so now I had to get the bottom part of the picture under way. The distance and the silhouetted shape of the church were stated with darker value mixes of cobalt blue and brown madder alizarin, which I also ran under the whole of the foreground shape, to be reclaimed later with a still darker value. I was trying hard to maintain a warm balance throughout the entire painting.

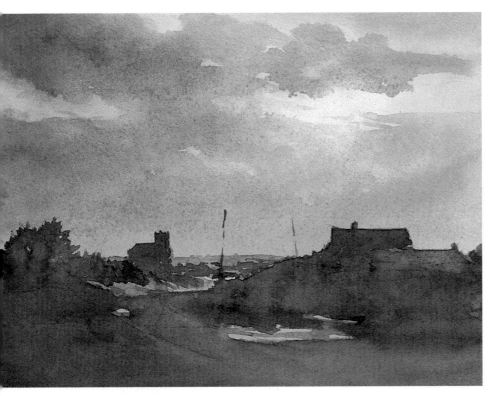

Step Four
At this stage I decided to add French ultramarine to give me a darker value in the foreground. Then deeper values of French ultramarine and brown madder alizarin gave it great depth.

Evening Glow, Ballyshannon, 10″ × 14″
Now I had to control myself as well as the watercolor. I was excited because I could feel that the sky had worked, and as this was what I had set out to capture, I didn't want to spoil it by getting too detailed in the foreground. If your sky is active and busy, then the foreground must not compete.

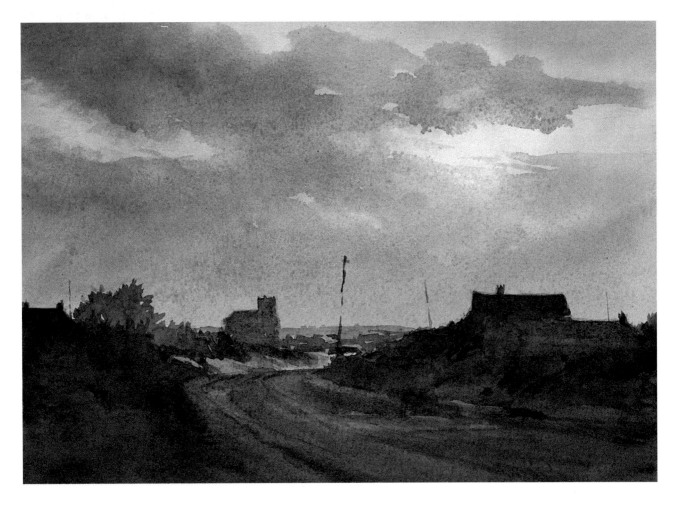

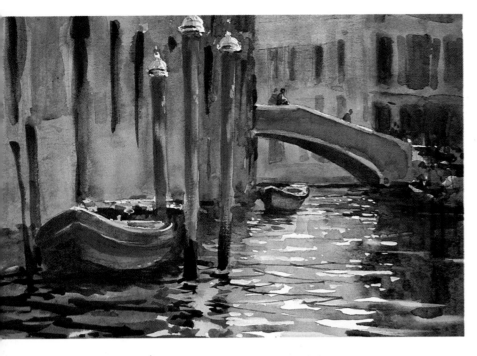

Side Canal, Venice, 10" × 14"
Subdued color, but the passage of light and the sparkle on the water give life and movement. Perceptive Observation just can't stop; your artist's eye is forever looking and searching!

Late Afternoon, Siena, 12" × 10"
The setting sun creates a glow on the hillside villas. That glow is what the painting is all about; everything else supports that feeling.

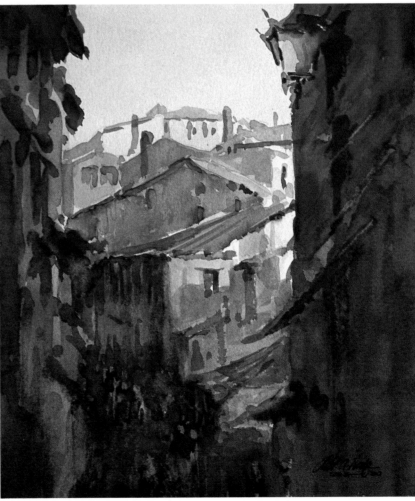

Venetian Textures, 20″ × 30″
Wooden shutters, balustrades, iron lattice, rust-marked stone, weathered posts, water
and reflections. Perceptive Observation is put to the test here. To keep areas from
competing for attention, we interpret the facts and present them as we feel them.

Passage of Light . . .
Step by Step

Step One
In this demonstration I put great empha-sis on the passage of light from left to right, and its glow back into adjoining shapes. I started with a minimal pencil drawing followed by a sky wash of aureo-lin and rose madder genuine carried through the whole sheet, except for that light passage. Very pale thalo blue was painted back into the damp sky area for a feel of morning, and distant trees were dropped in after that wash was almost dry. Aureolin and rose madder genuine were then worked in for glowing areas.

Step Two
I suggested buildings in the distance and middle distance, and then painted the large tree shape in cobalt blue and rose madder genuine. The building on the left was blocked in.

Step Three
In this step I was concerned with strengthening the values in the back-ground, the building on the right, the telegraph poles and tree, all in rose mad-der genuine and cobalt blue.

Step Four
Refining as I moved forward, still building up values, I put down a cool cobalt blue wash over the road as it gets further away from the light.

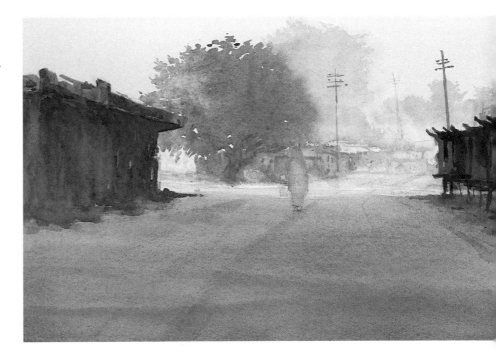

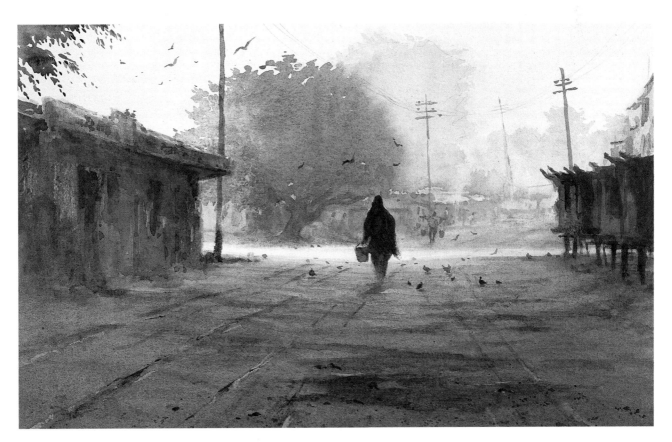

Morning Glow, Agra, India, 15" × 20"
The final touches: texturing the road, suggesting a tree outside the picture plane with leaves hanging into the lefthand corner. Strong darks to bring the lamppost and buildings forward. Then the coup de grace: painting in the very important silhouetted figure and birds. The values are spot-on and I hope the viewer will feel the urge to walk right into the picture.

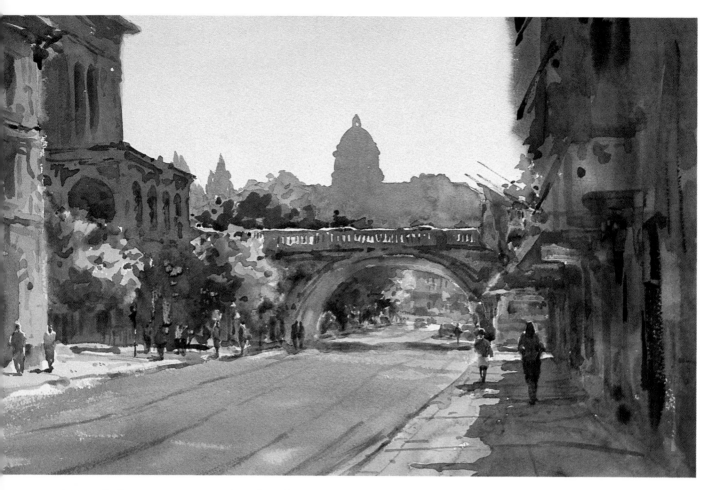

Towards the University, Zurich, 15″ × 20″
Here is another *contre-jour* (against the light) subject just off the Bahnhofstrasse.
Without Perceptive Observation of the highlights on the bridge, it's fairly average, but
that sparkle sets the rest of the picture dancing. Note also the reflected light under
the arch and the simplified shapes of the university buildings.

Alfama Shadows, Lisbon, 15½" × 13"
What if . . . I were to exaggerate the sky value in order to play up the white buildings?
A good strong abstract pattern was created in this picture, so evocative of Portugal.
The deep shadows are still very airy with an interesting dark-light-dark-light, checker-
board pattern within the shadow shape.

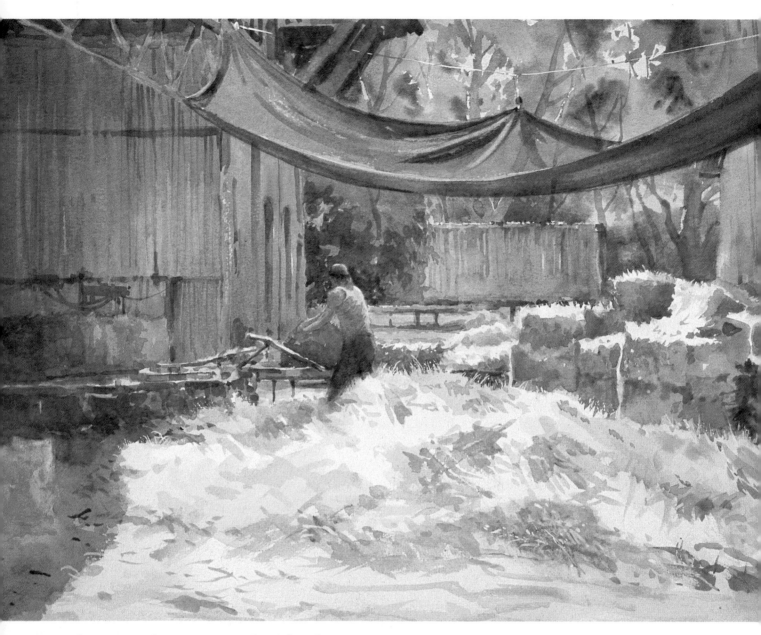

Baling Hay, York, Western Australia, 22" × 30"
Look at the brilliant Australian light and its bounce-back into the shadow areas. Can
you feel the heat? That shade-cloth awning will provide essential protection from the
sun as the day progresses.

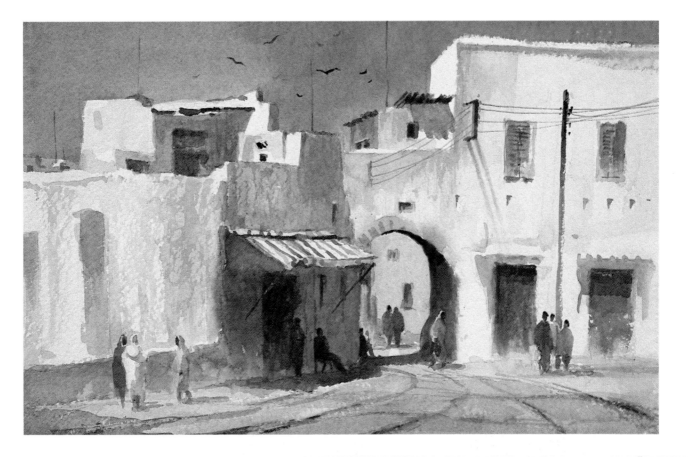

**In the Casbah, Casablanca,
15" × 20"**
Again, values were manipulated to emphasize the white facades. Figures, also invented, play their part in creating atmosphere and give scale to the arch and the buildings.

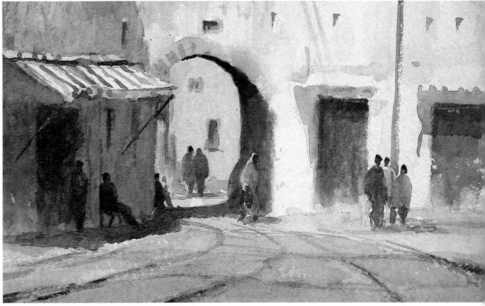

Detail. I had great fun inventing these guys. Gesture is so important in giving them meaning.

Chapter 5
Visioneering . . . in Depth

Are you old enough to remember the 1949 movie *The Secret Life of Walter Mitty,* starring Danny Kaye? Well, if you aren't, I'll just give you a brief rundown. Mitty was a character who lived in his own dream world, imagining himself to be all sorts of different heroic personalities, from fighter pilots to sporting champions. He was really Visioneering, though perhaps going a bit overboard. The point I'm making is, as an artist, you can project your emotions and your very soul into the subject; you can divorce yourself temporarily from reality and enter the mode of *Visioneering*.

It's not what meets the eye that excites a true artist. Often the casual viewer cannot see what would transform a subject from the drab to the dramatic, the impassive to the emotional, the boring to the exciting, or the ordinary to the extraordinary. How an artist envisages the subject matter is what determines whether it will become just another painting or whether it will become memorable *because of the feeling and character given to it by the individual interpretation of the artist.*

Seeing beyond the subject and inventing from your imagination is what I call *"Visioneering."* In simple terms, this means closing your eyes and conjuring up visions of your subject in your mind's eye, in all manner of different ways.

Visioneering With Light

Start by using light as your tool. Picture the subject in morning light, late afternoon light, winter or summer light, soft diffused light, backlight or under any other lighting condition.

Once you have determined the conditions that appeal to you most, run through the entire process again and, in Visioneering mode, decide on the mood: subtle, somber, romantic, mysterious, gentle, dramatic, exciting, serene or any other way you can dream up to paint the *feel* of how it affects you. Then you can put it all together and see the end result in your imagination. That's *Visioneering*.

And that's the way I try to capture the light and atmosphere of the different countries I visit. Visioneering helps me *feel*

rather than *see*. Sometimes the way to go is instantly apparent to me, but most times I have to work it over and over in my mind.

Visioneering With Color

How can we employ color to help convey the mood we've decided on . . . subtle color for subdued mood, high-key color, low-key color, and so on? Close your eyes once more, conjuring up the vision of your chosen subject. Mentally flick through the color options, simply imagining how each of those other images in your memory bank would now appear in these new color arrangements in order to show your feelings through paint.

Visioneering With Composition

With so many compositional alternatives to choose from, you must create additional visions. In your Visioneering mode, you can examine compositional ideas as you apply different design ideas to your previous images.

Exhausting? No way; this is the most stimulating area we work in. Here the real artist

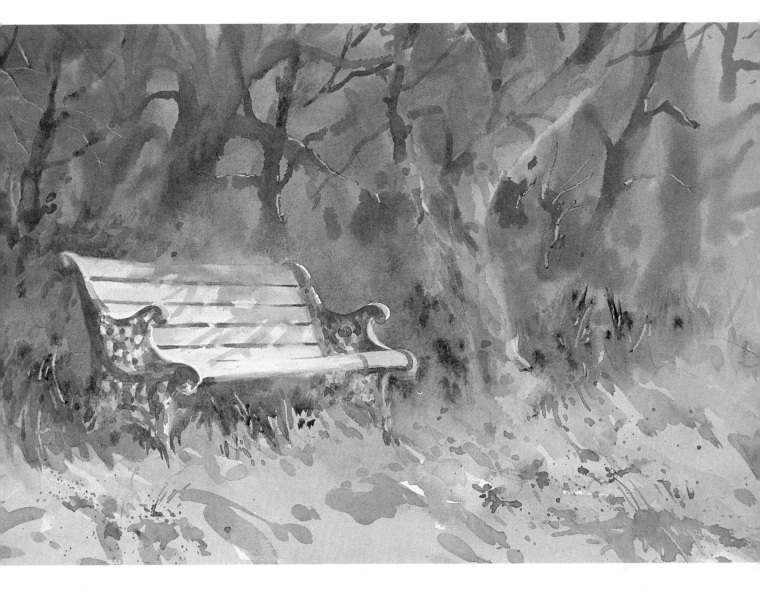

A Place to Dream, 15" × 20"
This is the painting produced later in the
studio, with Visioneering applied.

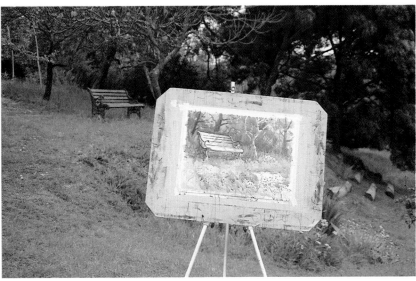

I set up my easel in this lush green garden at Muntham, in Victoria, Australia.

comes out . . . an interpreter of Nature, an innovator in design and color, a communicator of thought and emotion, a poet, a dramatist, a composer, a guide to those who look and do not see.

Putting Your Visioneering to Work

Once you have established the way you are going to present the work, it will then be necessary to do a few little thumbnails and quickies before you tackle the actual painting. You must know what you are about, what you want to say, and how you want to say it, or you will be preparing for irreversible failure caused by your failure to prepare!

Visioneering is a process you should reserve for studio work until you become used to it. But after years of experience, you will employ it in all your work as I do, including on-location painting. In the field I've often turned a summer landscape into a snowscape, or brilliant sunshine into mist and fog, much to my personal satisfaction but often to the complete bewilderment of those ever-present onlookers!

Visioneering allows me to investigate my subject and explore myself to discover those innermost thoughts that will help define the best method of communicating my reactions. As the years have rolled by and after a

Port Clyde, Maine, 20″×30″
These four quarter-sheet sketches were done for a class to demonstrate just how Visioneering allows you to use a subject as your starting point, then play around with it almost any way you want.

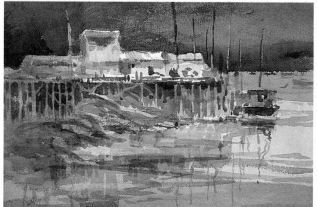

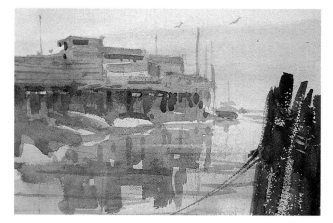

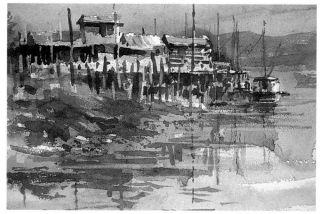

Morning on the Bridge, Toledo,
12″×10″
Visioneering said to change the blue sky to a pale yellow glow, then use its influence right through the painting. I like it a whole heap better than the original blue, which would have made it just the usual sketch. Now it has feeling and atmosphere. What do you think?

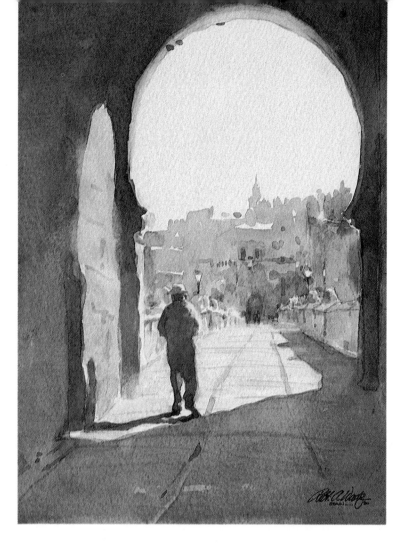

Santa Prisca by Night, Taxco,
Mexico, 11″×14″
Each night, from the Rancho Victoria, the floodlit cathedral dominated the landscape. Back home, with sketchbook reference for the cathedral, with memory, and with Visioneering, it was easy to recreate the scene. I can see the fireworks, hear the mariachi band and feel Mexico here.

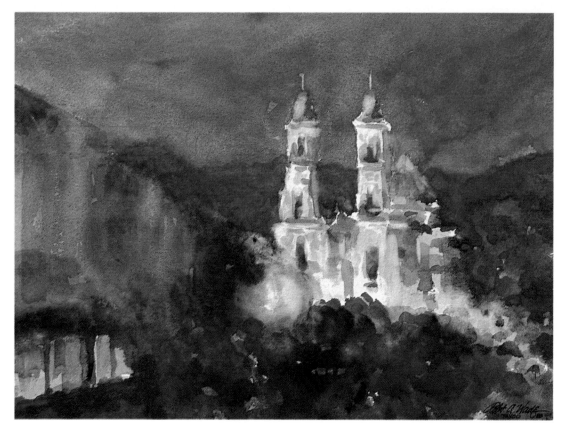

News From the Gulf, 20″×30″
I don't get involved in politics, nor are my paintings intended as social commentary. This is as close as I've ever come to it, I guess. Visioneering gave me a picture of ordinary people on "the other side" who also have children, who also live in fear, who also care about their loved ones away at war. This was a compilation from a couple of sketchbook drawings.

lifetime's involvement in art, I find myself searching more and more for subtlety, feeling and sensitivity in my work.

I want you to practice expanding your mental power with Visioneering. You'll need no materials, no space, and it will cost nothing, but the returns will be great. In addition to the heightened awareness you will discover from observing all that is around you and the newfound pleasure you will derive from painting

with the inner eye, your work will take a new direction, one that may lift you from the ordinary to a painter who is stamped with the power of the Visioneer. One thing I do promise you: The world will never look quite the same to you again.

Visioneering in Action
Now let me give you a very good practical example of what I've been talking about. A few years back, James Fletcher-Watson, the

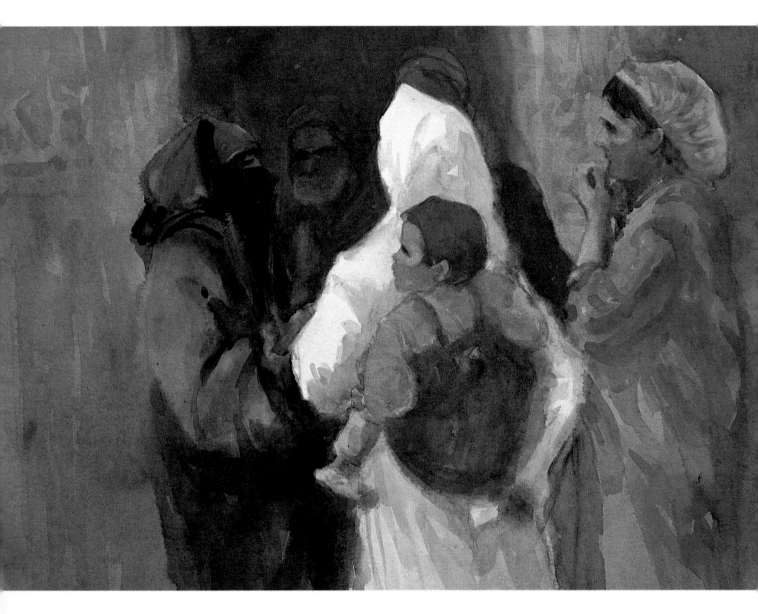

fine English watercolorist, and his wife, Gill, came out to visit us in Australia. James and I had a wonderful time painting together around the Victorian landscape. On one memorable occasion, Ann, Gill, James and I paid an overnight visit to Muntham, a historic National Trust property belonging to my brother-in-law. Next morning, James and I headed straight out into the gardens for a painting session, he to paint some of our native eucalyptus trees, and I to paint an old garden seat set amongst the bushes and shrubs.

As you can see from the photograph on page 43 showing the site with my easel and the completed sketch, my painting was quite literal. A typical on-site sketch simply records the day and the mood of the moment, and that is just what I did here as we were a bit pressed for time.

We enjoyed ourselves enormously, working at some distance apart, occasionally walking across for a bit of a chat and to see how each other's paintings were progressing.

Some weeks later, back home in my studio, I had an overpowering urge to tackle the subject again, this time as a Visioneer. So, in switched-on mode I imagined my recently deceased sister-in-law sitting on the garden seat. She had sat there often, writing her prose and poetry, surrounded by the cries of magpies, the screech of the white cockatoos in the distant gum trees, and the occasional laugh of a kookaburra. The city's bustle seemed so far from this haven of peace and well-being. I had a vision of dear Jo sitting on this seat and dreaming up the themes for her writing. This changed my concept of the subject, and I painted *A Place to Dream*.

An emotional, nostalgic at-

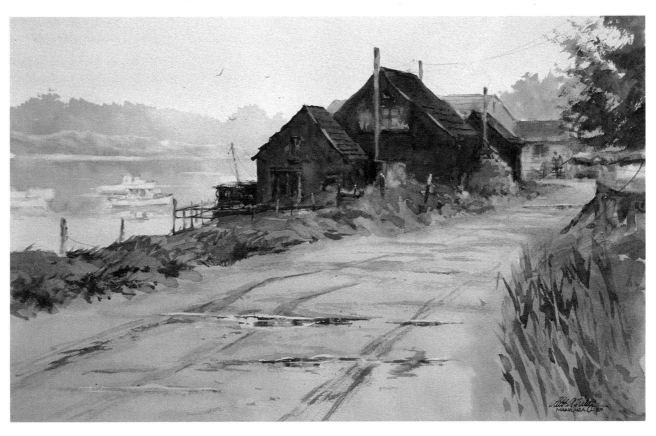

Lobstermen's Huts, Maine, 15″ × 20″
Visioneering says, What if . . . you change bright sun and blue sky to a misty feeling, which really does prevail in this area for most of the year? Invent a couple of puddles, silhouette the buildings, soften the distant trees and boats—yes, I think I've got it.

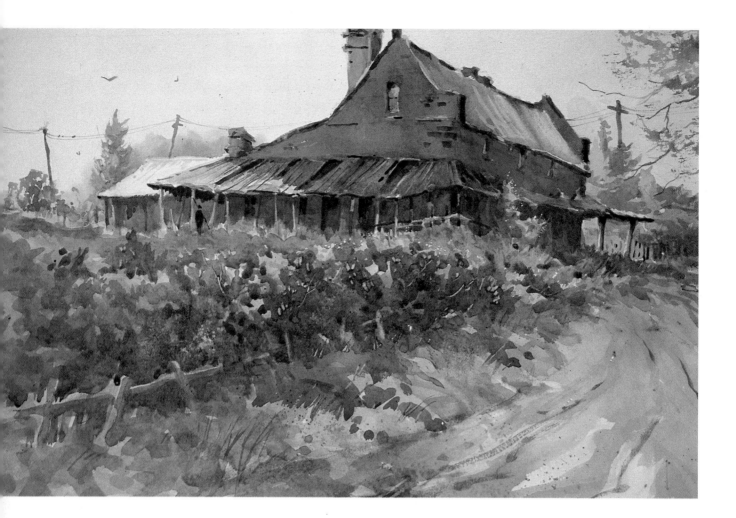

Old Farmhouse, Carcoar, New South Wales, 15" × 20"
This was a hot summer's day. I had my workshop students all agog as I explained Visioneering and then, applying it, modified the atmosphere by changing the strong cobalt blue of the Australian sky to a warm soft light.

mosphere prevails, with many soft edges and blurred shapes, all contributing to an air of mystery that I did not feel strongly on site, as James and I had been having such a good time.

I admit to painting this one with damp eyes and a lump in my throat as I constantly tried to capture the feeling of this place made so lonely by Jo's absence.

This was very special Visioneering because of my personal

knowledge of the site, but I hope that you can understand what I mean. Is my emotion showing there in the picture, for all to see? Can you feel it there, as I do? If you can't then I have failed, but it was my sincere endeavor to convey the *feeling*, not the *appearance* of the place. And that, my friends, is what Visioneering is all about.

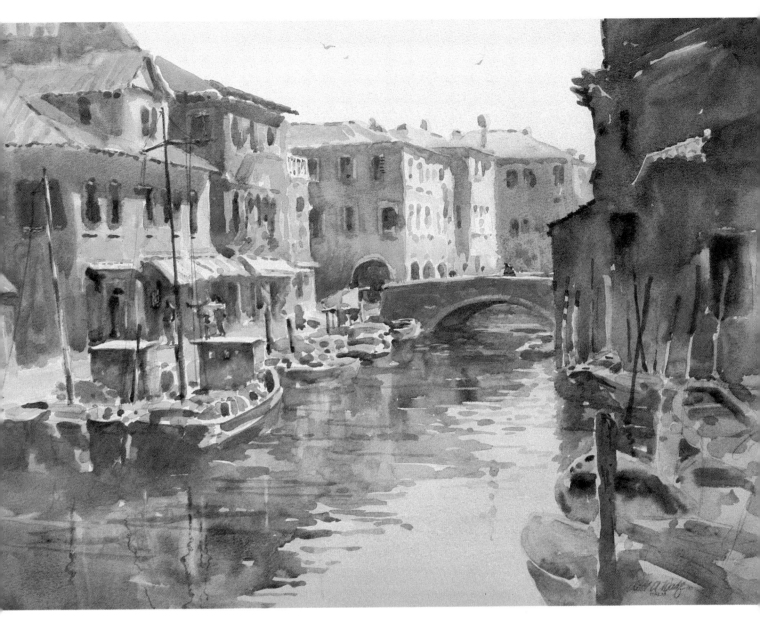

Canal at Chioggia, 20" × 30"
The actual light was not brilliant, but Visioneering told me to lighten the values of the buildings' facades and thereby deepen the values of the shadow areas. Perceptive Observation had already picked up the light passage. By using it in my way, I made it my slave, not my master.

Here's the Djemaa-el-Fna, Marrakesh, where it's possible to buy anything from secondhand false teeth to a mummy's shroud. I found a place on a hotel roof where I was allowed to sketch, providing I purchased a cola every ten minutes (at five times the usual price!), so I made it a quick drawing.

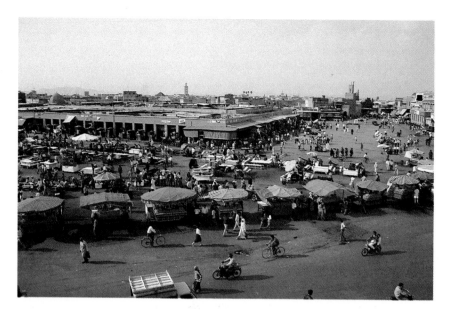

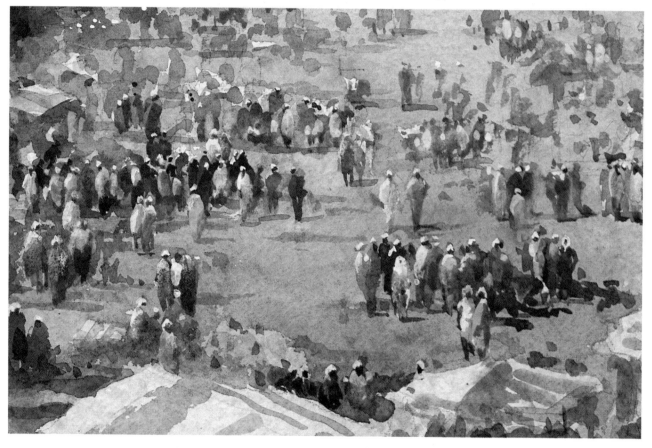

Detail. Back at my studio, Visioneering gave me images of the Moroccan figures. I let my brush play around, creating simple indefinite blobs in the background and increasing detail in the foreground. I did use gouache to dash in the headgear and some highlights on the many scattered figures.

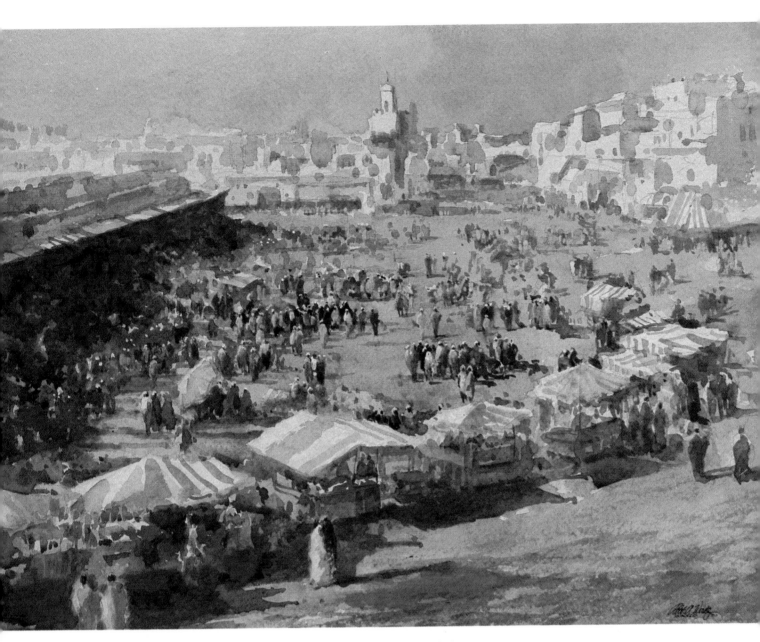

An overall initial wash of aureolin and rose madder genuine set the warm feeling. When glazed over in cobalt blue, the underpainting shines through with the impression of warmth. Notice the color of the shadows on the buildings.

Sketchbook drawing . . . minimal line . . .
five minutes at most, or the group's
passed me by and gone down the track.

Could I transpose those few lines into a
full-sheet watercolor? A few preliminary
drawings were done on scrap paper, and
when I'd Visioneered a result I began the
drawing, trying desperately not to lose
its simplicity. The first wash of raw um-
ber and Winsor violet went over the
whole surface except where highlights
were reserved. No masking here. I
hardly ever use it as I like to prove to
myself that the brush is under my
command.

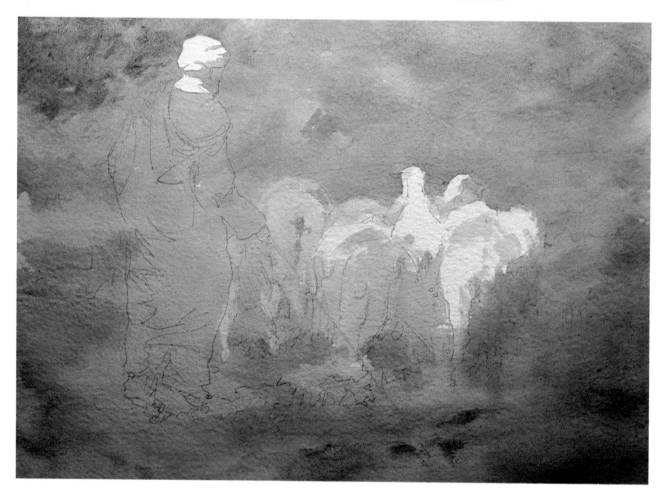

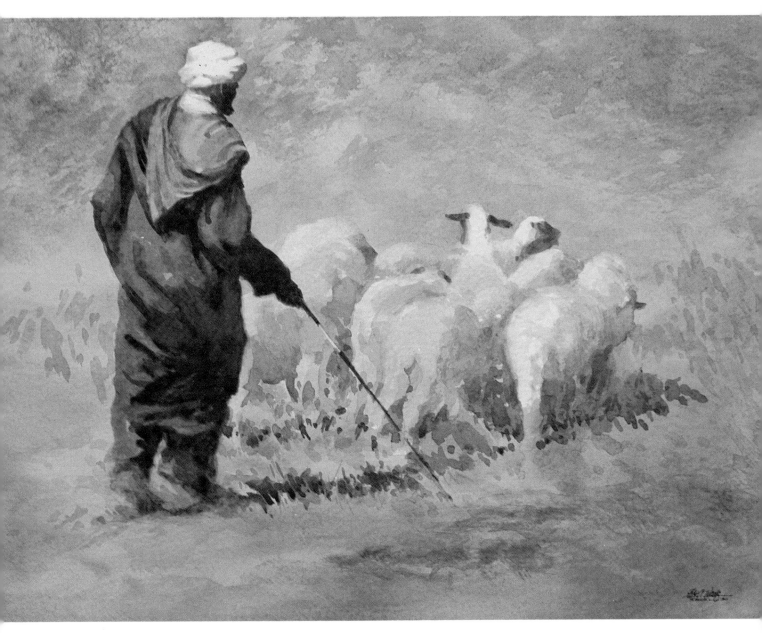

The Shepherd, Morocco, 20″ × 30″
Not much was needed to carry the image through — some background texturing, contouring of the shepherd's cloak, and some colorful shadows around the white blobs to trick the eye into believing they are sheep. Much Visioneering from go to whoa!

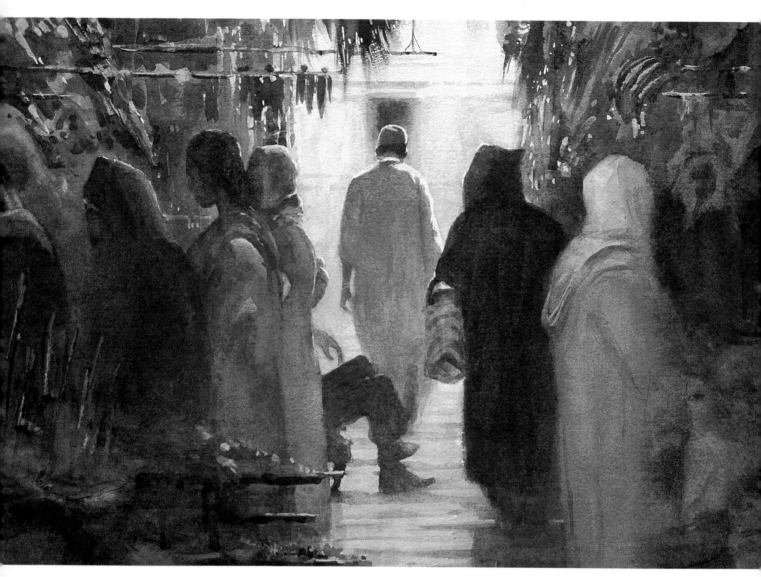

Light in the Souk, 20" × 30"

The market in Marrakesh. Visioneering worked hard to build up the image of the figure emerging from the Souk's gloom into the sunlit street beyond. The rest was imagination. I invented the sitting figure to give a link from the left to the right side of the picture so that I might avoid a light value division down the middle of the painting.

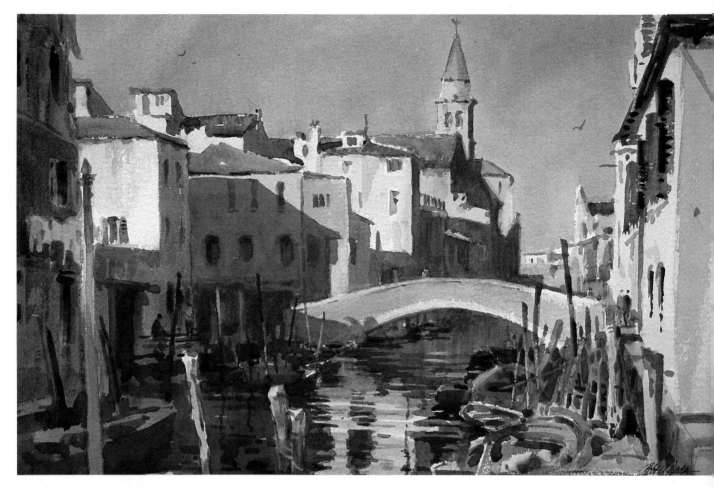

Sunlit Canal, Chioggia, 15″ × 20″
The magical fishing village of Chioggia where Sargent, Russell Flint, Seago and so many fine artists have painted. It's difficult not to be influenced by what others have done. However, Visioneering gave me deep blue-purple shadows from a slightly diffused late afternoon sun and a vibrant light passage helped to set these shadows up. I don't think the painting looks at all like any of theirs.

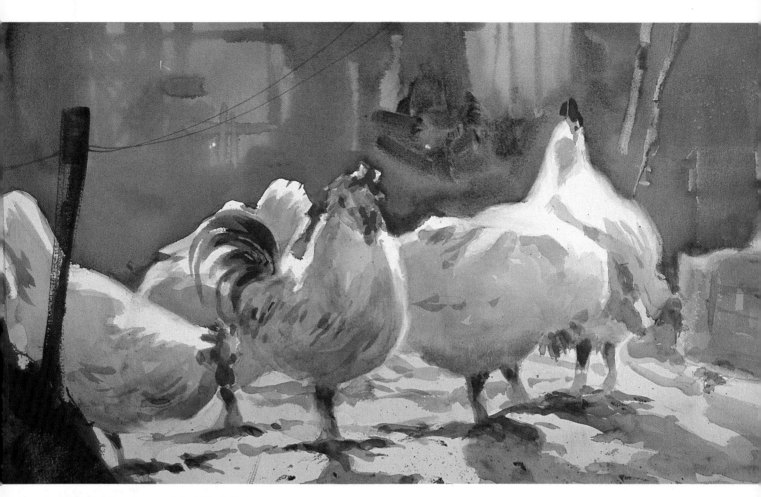

Light in the Farmyard, 18" × 24"
This was another demonstration painting. Strong back lighting on the chooks (chickens) makes a great pattern, which is set up very starkly against the soft wet-in-wet background suggestion of old sheds, fences and so on that Visioneering conjured up. I made no attempt to paint those birds with much detail as it's only their forms I'm after, not their portraits.

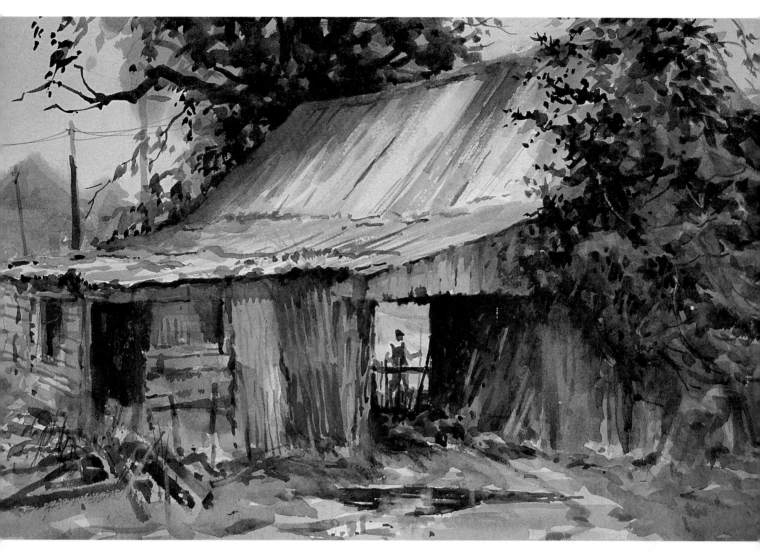

Old Shed, Millthorpe, New South Wales, 20″×30″

This on-site class demonstration was all about textures . . . corrugated iron, timber, foliage, and so on. By Visioneering the dirt track, puddle, reflection, and figure on the other side of the shed, more life and interest was created than simply painting it as it appeared.

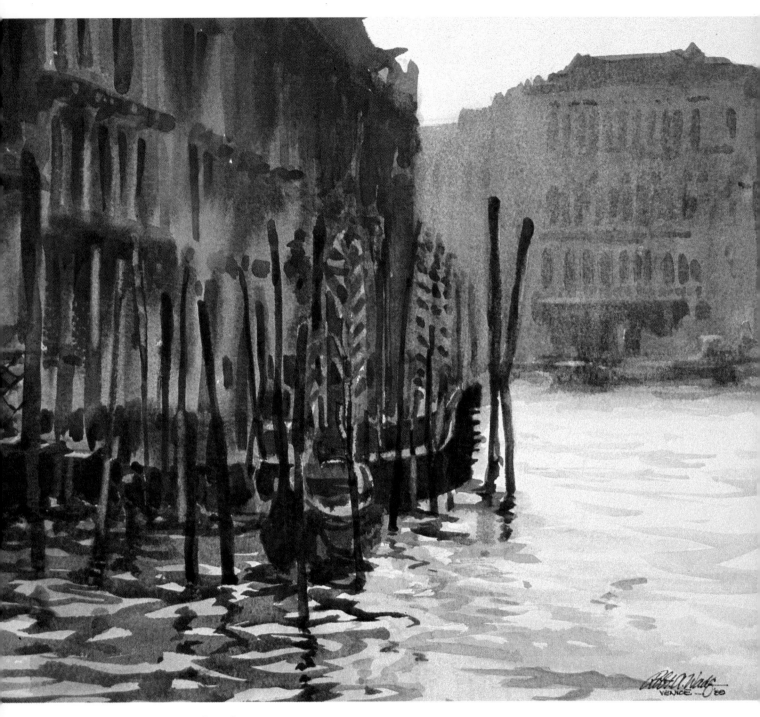

Golden Canal, Venice, 10" × 12"

This small watercolor is very simple, with little detail. Visioneering suggested to me
that an effect of soft light as the canal turned the corner would be a good idea. So,
when it was all dry, I painted clean water over that area of the distant Palazzo and
wiped color away with a tissue, repeating the process until I was satisfied.

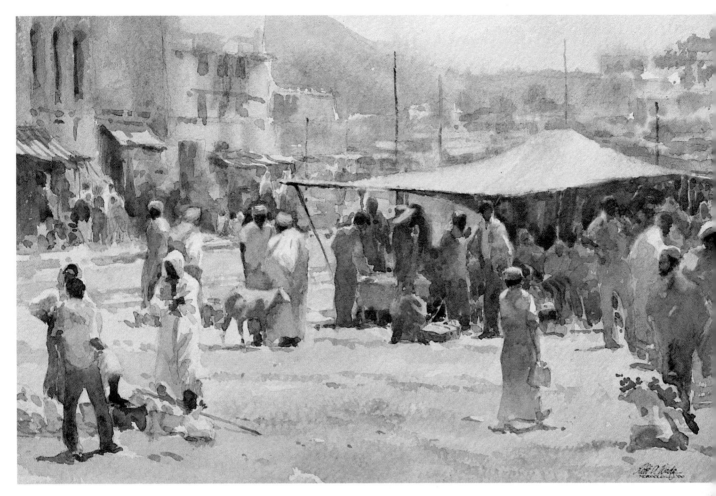

Moroccan Market, 15″ × 20″

What if . . . I created a market scene by using an assembly of figure drawings from my sketchbook? Visioneering then ran me through some of the possible ways of building up the atmosphere and I selected a high overhead noon light. As long as I always remembered where my light source was, I could ensure that shadows rang true. Note the lack of detail in the distance; there's plenty going on in the middle distance and foreground, so I kept the background quiet.

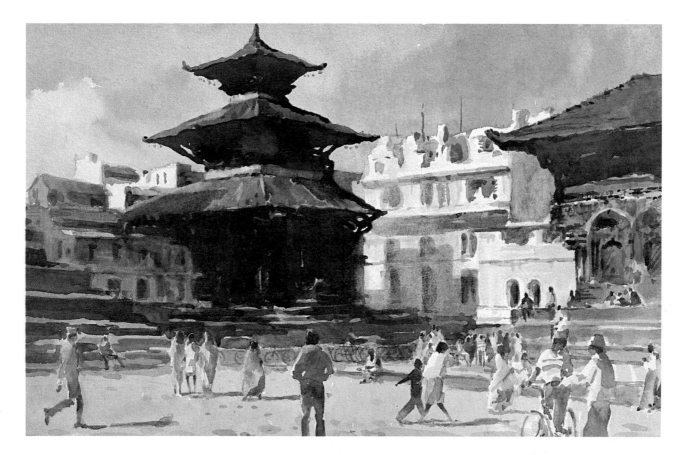

Temples, Kathmandu, 15" × 20"
Here's a different atmosphere, different
light effects and different people. How
to portray this required a mixture of Per-
ceptive Observation and Visioneering.
Perceptive Observation saw the architec-
tural styles, the light passage and the
pose of the figures. Visioneering allowed
me to *feel* the atmosphere of the place.

Rooftops, Taxco, 10" × 14"
The Roman-tiled rooftops and white stuccoed walls suggest this jewel-like Mexican
silver mining village. Perceptive Observation saw the colors in the shadow of the roof
on that white facade, recognized the warm light bounce in the shadowed walls and
lowered the value of background hills, trees and sky to accentuate the light.

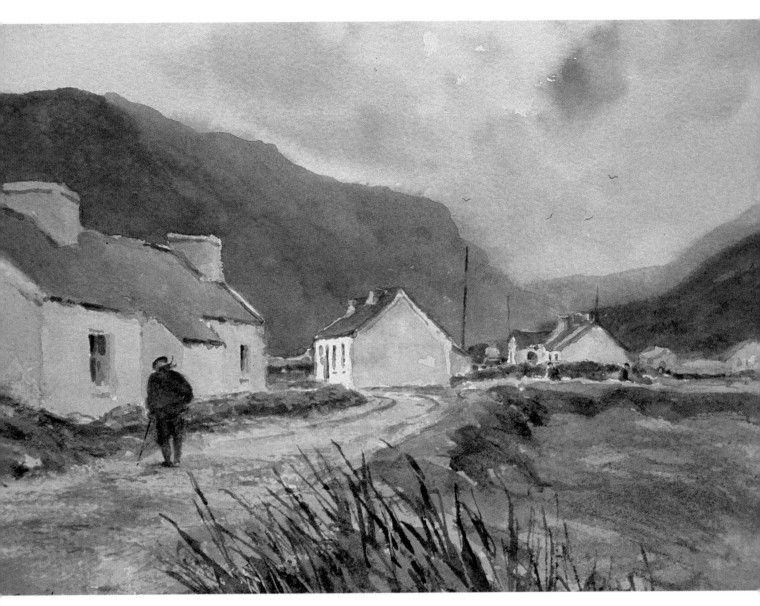

Maghera, County Donegal, Ireland, 10″ × 14″
A typical Irish subject, and here's a light that is totally different from Morocco, Nepal or Italy. Compare this with some of the others and see the softness that comes from *this* diffused sunlight. Now you'll recognize the problem that constantly confronts the traveling artist, but Perceptive Observation and Visioneering will help you understand and overcome it.

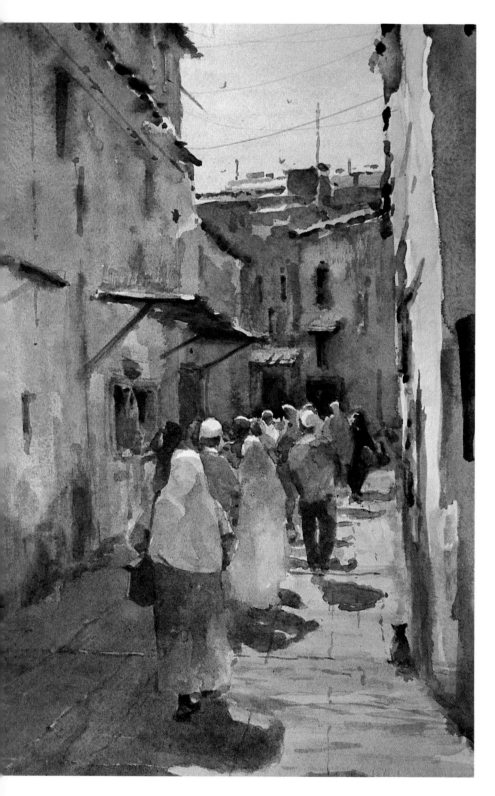

***In the Medina, Marrakesh,
20″ × 15″***

The warmth of the North African sun permeates every area of the subject. What if . . . I were to wash aureolin and rose madder genuine over the whole sheet except for a few highlight reservations on the figures?

By doing just that, it permitted the warm underpainting to show through in all shadow areas, filling the subject with the feeling of warmth and light. Get the idea? Search for a color influence to assist you to capture the mood of a place.

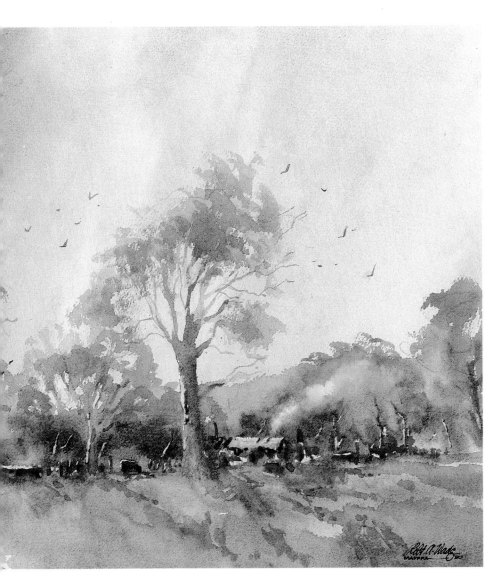

Grey Morning, Maffra

As we've seen in this chapter, the immediate subject is only the starter. How you feel about it and treat it makes it your own interpretation. I wanted to change the mood of the landscape in the photo to a gray morning. Why? Because Visioneering had shown me an image that seemed to suit the subject better and to make a more interesting painting. That was how I felt about it at that time. The next day, the next week, I'd probably feel different about it and paint it in quite a different manner. I may not be right, but that's the challenge, isn't it?

Landscape at Maffra, Victoria, Australia.

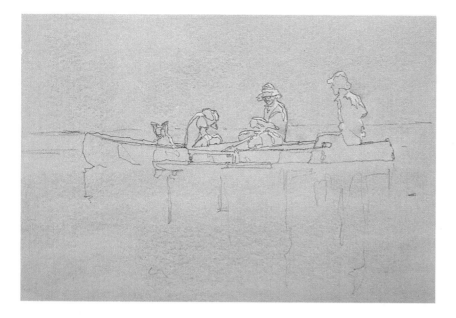

In the Everglades, Noosa, Queensland

In this four-step demonstration I want to put into practice the things we've been discussing about Perceptive Observation of light and form, color influences and mood, all examined with Visioneering.

I start with a very careful drawing of the figures and canoe—they *must* be correct—and a rough indication of reflections, and that's it. I'll let the brush take its course as I progress. I flow a wash of aureolin and burnt sienna over the sheet, except for highlight reservation. Again no masking fluid, just very quick footwork.

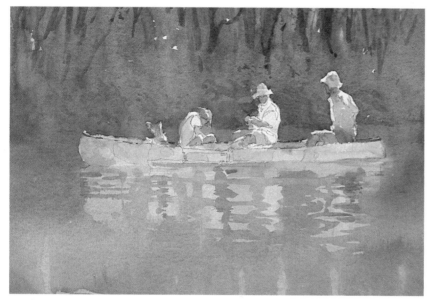

A wash of Winsor violet, burnt sienna and cobalt blue goes over the background, cuts around the figures and runs down across the water, leaving some of the first wash for reflections. A few tree trunks are popped into the nearly dry background, and a beginning is made on the figures, dog and canoe. Every value is light, leaving all options open.

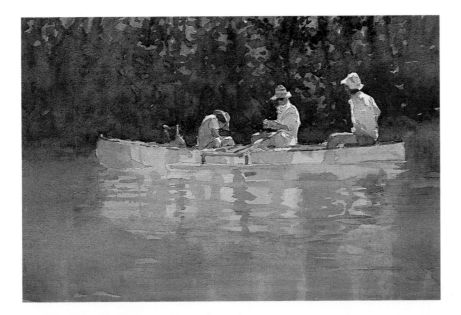

I work up the background area, leaving areas of lighter value for depth, and darken figures here and there. The water is untouched from the previous stage.

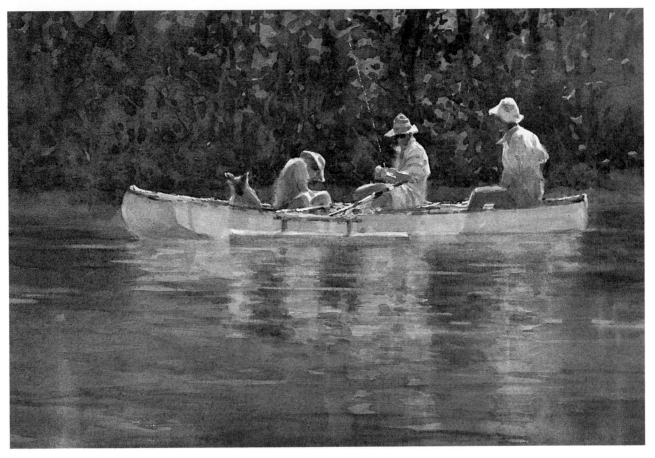

Final touches include a glaze over the water; a subtle deepening of the shadow values through the transparent canoe; a strengthening of colors, shirts and flesh values; a bit more work in that background area with indications of foliage; and some movement on the water. We're there.

Alleyway, San Gimignano, 20" × 15"
Another example of a strong silhouette.
This class demonstration has the mood
set once again by the sky. That warm
pink sky shape radiates warmth, and
while it's not factual, it's poetic. Exagger-
ated light-bounce in the wall shadows
and the strip of brilliant light running
across the road and the building set up
a theatrical spotlight for the positioning
of the figure.

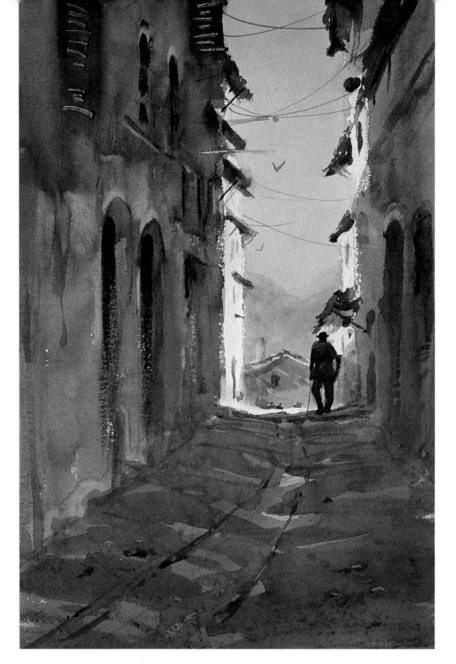

**On the Rocks, Phillip Island,
Victoria, 10" × 14"**
The light from the sky is the key again.
See the golden glow in the distant hill
and the water? The silhouetted figures
need no detail, just a correct observation
of their shapes and attitudes. Look at the
birds—the sun turns them to gold, too.

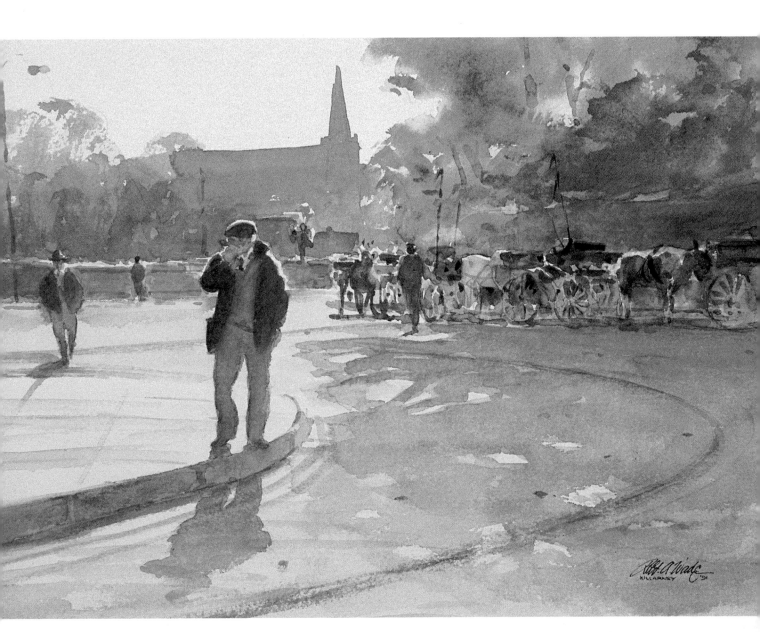

The Cab Rank, Killarney, 10" × 14"

In this high-key, contre-jour subject, notice that the silhouette is not nearly as low in value as the previous two examples. Visioneering showed me a way to keep the light very soft and cool. Even though the foliage on the right shows that there is some sunshine, we know it's pretty cool, as the cabby has a warm jacket and pullover and the shadows are quite pale and cool in temperature.

The waiting cabs and horses flow along into each other to eliminate the risk of too much detail catching our eyes and becoming overly important. Perceptive Observation noticed that important highlight that passes along the church wall and haloes the cabby's shoulders and cap.

Chapter 6
Painting From the Mind's Eye

Now I want to tell you about another way of working that I find to be enormous fun: Painting purely from memory and imagination . . . from the "Mind's Eye."

This becomes the ultimate test of Visioneering, as you can no longer look at any sort of reference whatsoever. Every decision you make about light, shape and color will be influenced by the vision you have created in your mind or by the picture itself as it evolves before your eyes, prompting different reactions from you as it dictates which way it wants to go. Here is the ultimate painting excitement. It's composing a symphony, writing a play, inventing a mystery plot. It's whistling a tune straight out of your head with no holds barred.

My wife, Ann, and I had a visit to St. Thomas in the U.S. Virgin Islands a year or so back, albeit a brief one, and I only had time to paint a couple of quick sketches and shoot a roll or two of film.

St. Thomas, U.S. Virgin Islands. Here are some examples of the small cards that came just from my mind's eye after our brief visit. Color ran riot, and one thing just led to another. I had so many memories of these wonderful figures, they were there just waiting to pop out.

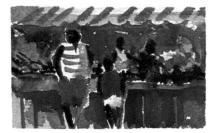

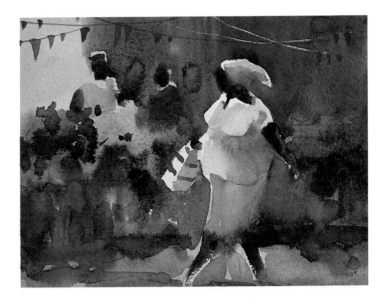

I just kept going, inventing, refining and letting that scallywag of a brush have its own way.

After Christmas I looked at a slide of this little card and thought I'd paint a full sheet of it. It was a disaster. Totally lacked the spontaneity of the small one. Oh well, that's life.

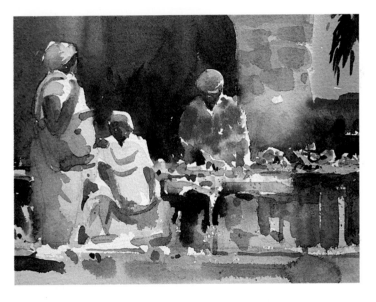

It's funny how things happen with watercolor when you're not being careful. Colors have run into each other, but who cares? If only I could transpose *this* freedom into a larger work.

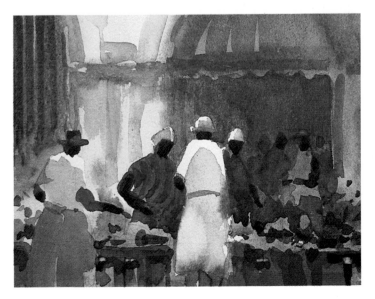

This time I drew on my memory bank and Visioneering to come up with little 7 × 2½-inch paintings of Moroccan souks (or markets). They represent no particular place but are all evocative of the atmosphere.

I simply played with color and had a great time seeing what would happen when I put down warm washes, then glazed cool over them, and vice versa. There was no preliminary drawing of any kind. I just reserved some white paper in one area and turned it into figures. Not only was this a very useful learning exercise, but it also gave me a bundle of interesting Christmas cards to send. The big bonus, though, was that it provided me with so much fun.

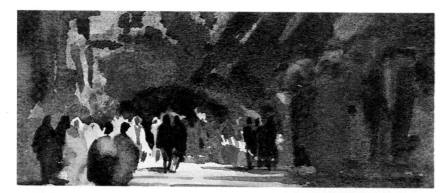

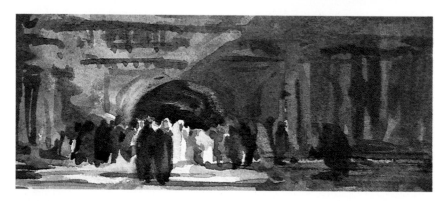

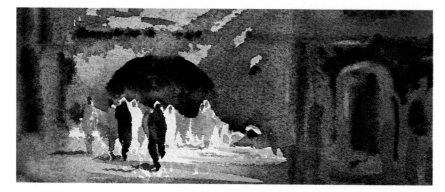

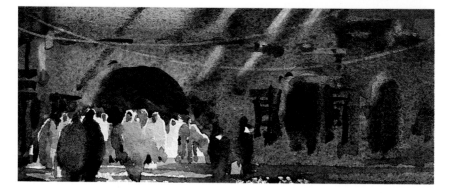

After arriving home in Australia I had a number of images running around inside my head. They were of markets, tropical flowers and fruits, color, music, laughter, dancing Islanders and a feeling of joy and fun.

It was all so free and uninhibited that I wanted to feel the same . . . no restricting influences like color slides or sketchbooks, no nuthin'. I just wanted to paint the memory because I felt so strongly about it.

As it was nearing the end of November, I knew that it was time for me to start on my Christmas cards for overseas friends. I thought this could well be the opportunity I wanted. This was where I could let my hair down and allow my imagination to run riot.

I taped my watercolor full sheet into card formats and sailed in to paint the images that Visioneering had created in my head. Boy, what fun it was! No pencil drawing to start off, just a blob or three of color to suggest the heads of Islanders, adding bodies and background suggestions. As they began to develop, the odd pencil line helped me create a visible rendition of my imaginative ramblings. Each little 6 × 4-inch image took about ten to fifteen minutes to complete, and I enjoyed myself so much I finished painting forty of them.

Some days later the slides of our visit to the Islands were returned from processing, and when I looked them over, they seemed a bit dead and lifeless compared to the spontaneous little watercolors that had just seemed to "fall off the brush."

Why don't you give it a go? Don't attempt anything too serious; keep it simple, splash color around and have a great time. You may just surprise yourself!

On other occasions it is a matter of building on a simple foundation. *Maine Coast Patterns* (below) started out as a class demonstration on painting a soft, misty atmosphere. I decided I would have to carry it a little further than I had planned and invented a distant fish house plus a foreground building and a jetty. Each new shape I invented suggested another one plus a couple of alternatives.

The Nuns (page 73) unfolded through quite a number of attempts to clarify an idea that had been bugging me for a long time. I was watching television one evening, when a second-rate movie about a young novice nun came on. I was just about to change the channel when I no-

Maine Coast Patterns, 15" × 20"
I just went along with what the picture told me to do, inventing, building and playing with lights and darks . . . great fun!

ticed what fascinating stark shapes the nuns made. So I continued to watch the film for reference and made many quick drawings in my sketchbook.

Only a day or two later I was going through some books in my library and I came across a painting of nuns by Sir William Russell Flint and then, in another book, one by Walter Sickert. Next thing, Ann showed me an old photograph of French nuns taken by her father. I determined to pursue my "nun theme" at the earliest opportunity. However, as I was about to depart for Europe, the ideas were put on the back burner. Then, in Paris, out of our cab window I saw what I wanted.

I glimpsed some nuns of the order that wears those huge winged headpieces. All my previous thoughts flashed back and I decided I would develop a painting around the memory I had of these ladies and their incredible white sails.

I started with a small pen sketch, followed by a pencil study, then two quarter-sheet sketches, and finally, a vertical half sheet. Each step along the way further polished and fine-tuned the shapes and values to convey the feeling I was constantly building with the assistance of Visioneering.

Any way of working up a picture is valid, provided that it is your own interpretation of a subject or a set of facts. Just give it your best shot and be honest in your intentions.

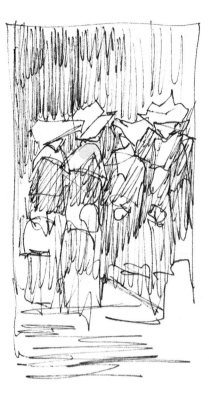

First, I inked a quick line drawing before the glimpse of these nuns faded from my memory.

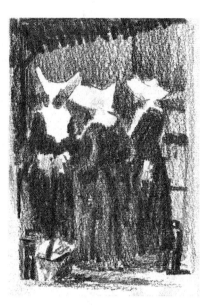

The next step was a value sketch in pencil, clarifying my images before getting too involved in details.

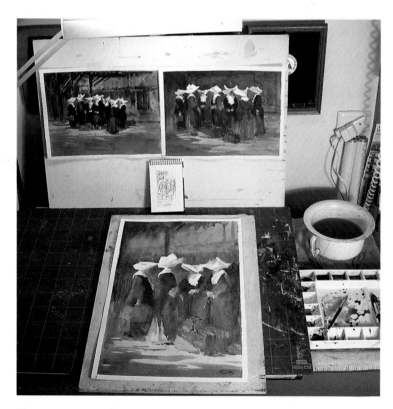

Then on to two early quarter-sheet studies, building the shape by adding more nuns and filling a landscape proportion.

If I can communicate one big thought to you in this book, it is this: Let us, you and me, try to paint with our hearts so that people may view our work and feel what we felt. Whether the feelings are sad, mad or joyous doesn't really matter. But please let there be a love of what we are doing manifesting itself and becoming instantly apparent to the viewers. ***Let us have EMOTION coming back into painting.***

Now that I've convinced you that determining how you feel about your subject is the most important aspect of painting, let's get down to some more practical matters. How are you going to communicate your vision in watercolor if you aren't fluent in the language of watercolor? In the next section I cover the crucial elements of the painter's language, including drawing, color, values, and more. Please read on. So far you have only half the picture. Now, let's get cracking!

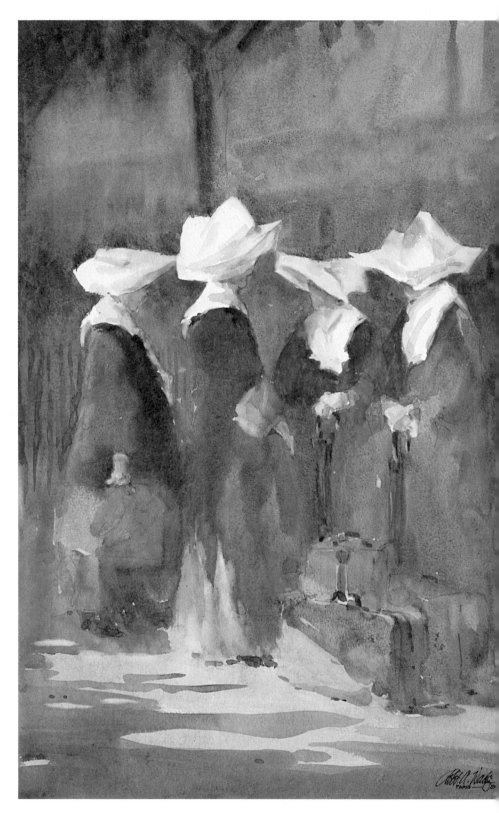

The Nuns, Paris, 20" × 15"
I really felt that I knew Sister Francoise (I gave them all names) and her associates after all this time. More important, I knew where I was going even if they didn't. I just love those big white sails. Imagine wearing one in a spanking breeze!

Section 2
Let's Get
Cracking . . .

Chapter 7
Drawing . . .
Where It All Begins

At the risk of sounding academic, I want to emphasize the tremendous importance of developing your drawing skills. The more you improve your drawing, the better your paintings will be. Once you have drawn the true facts, you may depart from them in whatever way you desire, but if you wish to paint in a representative way, *drawing* is the basis for all good painting.

The pencil drawing forms the foundation of my entire plan for a painting, though I know that my self-willed brush will certainly make frequent departures from that plan as I paint along.

As it evolves, the painting will tell me just where I need to revise my course of action and to depart from the original guidelines. Alterations may be necessary to suit a new mood or direction that has suddenly been dictated to me by the watercolor itself. But because my foundation is sound, I am able to distort the original in any fashion I please. Of course, because I'm essentially a traditional painter, I need to observe the basic truths of perspective and scale to be faithful to my own beliefs.

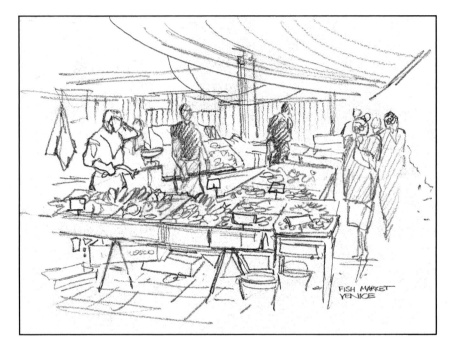

Notre Dame, Paris

Various Approaches to Drawing

I am a great admirer of the wonderful drawings of Paul Hogarth, which are so full of character and personality. *Graham Greene Country* (Pavilion Books, UK, 1986) is one of my favorites, depicting many scenes from Greene's best-selling novels. Hogarth's wonderful watercolor and mixed media drawings have immense charm and are completely individual in style. He will even distort perspective, with some very interesting results. The purist may shudder at the liberties he has taken, but by so doing, he has injected the subject with his own very individual way of seeing. Behind every intentional distortion Hogarth makes there is the mark of the master draftsman. It is only because of his enormous drawing skill and knowledge that he is able to interpret his subject without sticking to absolute reality.

There is also the pure art of drawing, where the drawing is complete unto itself, but I won't elaborate on it here. This section is about drawing as it applies to painting, and we are looking for more of a sketching approach.

The Sketchbook Habit

I want to get you hooked on the sketchbook habit, as I believe that it's the most useful way to develop your drawing skills, powers of observation and selection

processes. Not only that, it really is terrific *fun* (there's that word again). As your drawing improves, it will become an even more enjoyable pastime. It will become a vital part of your life, and a sketchbook will be another item among your basic personal effects, like a purse or a wallet. Don't leave home without it!

There are so many different sketchbook sizes and formats that you'll have no problem finding one that suits you perfectly, one you can slip into a handbag or a jacket pocket. I prefer the spiral-bound books myself, as some of the others tend to lose their leaves over the years.

It all comes down to personal preference. The same applies to the sketching tools you choose, such as technical pens, markers, graphite pencils, fountain pens, ballpoints, sharpened sticks and

inks, carbon pencils, colored pencils or whatever. The tool is not important. What *is* important is that you feel comfortable with whichever instrument you are using. I usually work with light-fast waterproof marker pens as they are very suitable for what I do. I carry a small pouch containing pens of differing line widths, from 0.1 through 0.8. I also include one black water-soluble marker; if I wish to record a pattern of values I can lick a finger and smudge the ink for a half-tone effect.

Sketchbook Diaries

Sketchbooks that record your travels become like diaries. It's a good idea to make little notations about the date, weather, name of your hotel, dinner companions, and any other bit of trivial nonsense that occurs to you

while you are in the area. Later, when you open to that page, all those memories will come flooding back, and you will be able to paint from that sketch with all the feeling that was there when you were originally prompted to draw it. The quick sketches on these two pages are a good example. I wanted to capture the feeling of an Australian rodeo—the action and gesture of the cowboys and their horses, the constant movement and the tilt of the hats. These sketches, along with some fast-action photos, helped immeasurably when I returned to the studio to paint. See page 125 for the finished painting inspired by these sketches.

It's so much more rewarding to have your trips encapsulated in this fashion, making use of the ability and talent you are so fortunate to have; it's far better than rummaging through a heap of postcards and travel brochures.

It's Worth the Effort

I remember one workshop student whom I considered to be a candidate for some extra drawing tuition. She had a great sense of design and a wonderful feeling for color but suffered from a very deficient drawing ability. When I asked her to bring along her sketchbooks for me to see, she admitted with some embarrassment that she'd never realized that a painter had to draw! I soon put her straight on that score, and I'm pleased to say that she recently attended another of my workshops, this time complete with sketchbooks, which she now uses constantly. Believe me, her painting has improved out of sight!

If this story could also apply to you, then I promise you the same result, but only if you will start working on your drawing. *It will never improve by your simply hoping that it will.* You must work, work and work at it if you seriously want to improve your drawing ability.

Once you have overcome your initial reluctance to work at something you formerly considered to be academic and uninteresting, you will start to discover the satisfaction of producing drawings of a very personal style and character.

Rodeo..
Lang Lang—

Chapter 8
Values . . .
A Vital Component

If I could give you only *one* piece of advice in this book, it would be this: Take great care in searching out the *values*. They are so vitally important to the success of your paintings. Along with drawing they determine whether your painting will work or fail.

The most common fault I see in students' work—and I see it wherever I travel—is the *lack of recognition of the values in a subject*. The questions of "How dark?" and "How light?" are not properly addressed or understood. Consequently, paintings without punch line the wall as Critique Time comes up in the workshops. One or two will always jump out at me, and they will invariably be the pictures where values have been correctly observed and planned.

Recognizing Values
Here's how to assess your paintings for values. If there are areas where you feel you need to outline shapes to help them stand out from their neighbors, then your values haven't worked. The shapes are either too light or too dark to be distinguished from their surrounding shapes. Or it could be that the neighboring shapes themselves are incorrect values. *They* could be the culprits; they may not be dark enough or light enough to contrast with the shape that is not working. Your solution will then become clear, and you can make the necessary value adjustments to bring that shape back in line. Suddenly your painting will begin to work. Thank goodness you didn't destroy it—you were close to ripping it up, weren't you?

Here are a couple of clues: If you have a light shape, then its neighboring shapes must be dark enough to make it stand out. The *darker* those neighboring shapes are in *value*, the *greater* the *contrast* will be. (See the value scale below.) The converse also is true with dark shapes against light shapes.

Once you really understand those basic premises about the use of values, you can control the *contrast* to suit yourself. For example, the more the light shape moves in value towards the dark, the lower the contrast becomes. Simple when it's pointed out, isn't it? From now on, whenever you look at a subject, begin thinking *shapes and values*.

On this chart showing the gradation of values from dark at the left to lighter at the right, compare the horizontal white and black lines with their adjoining values. See how the contrast of the black line is greater where the values are lighter, but the contrast of the white line is less at that same point.

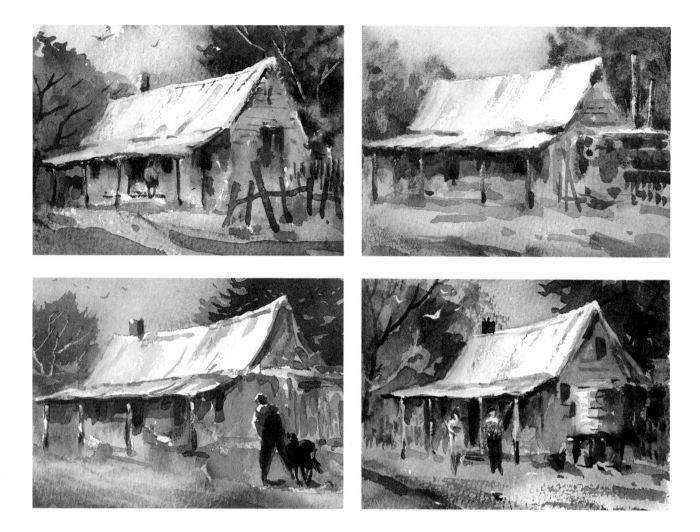

Translating black-and-white values into color always troubles some painters. Often when we dip into that wonderful palette of colors, we get blinded by the richness and brilliance of the hues. We overlook the *value* aspect of color. By showing you four versions of a similar subject—one in black and white, the other three each in a single color—I hope to make it absolutely evident that *any* color has a range from near white to near black. Now it's up to you to keep that fact in mind when you apply color to your paper.

Focal Point

By thoroughly understanding and controlling values, you will also be able to emphasize your focal point. You can direct the eye of the viewer through the painting simply by emphasizing darks and lights just where you want them. The Old Masters knew all about this painting procedure. If you examine the work of Rembrandt, Van Dyck, Velazquez, you'll soon discover they all used values to their advantage.

I will never forget seeing a small head study by Van Dyck on display in the National Gallery, London. My guess would put it at about 12 inches by 10 inches, but though it was small, it made an enormous impression on me. The eyes—I swear—were actually moist and I was certain that if I were to stick a finger in them they would water! This illusion came about not only from masterly painting but from masterly use and control of values. It was also an example of master Visioneering, which I am certain has always been a natural part of the stock in trade of all the greats.

***Palace That Way, Ma'am,** 14" × 10"*
Apart from the white hat, this is really only a two-value job. Excluding the small flesh areas, 95 percent of the painting was accomplished with French ultramarine and burnt sienna. Where does the little old lady stop, the policeman start, the fence begin? They all join together to make one unified shape with a few subtle color and value changes.

Create Your Own Values

Let me reiterate that the knowledge and control of values put you in the driver's seat. You can alter the values of what you are actually seeing to suit the way you *want* to portray that subject. You'll be giving it your personal stamp, your very own interpretation of the facts, and presenting a character and personality that could not be reproduced on film.

Your interpretation of a chosen subject may not look much like the actual thing, but remember that painting is a creative process; it is not painting Nature just as it is. Nature will always be the source of the creative urge, but as your work evolves, many influences will cause you to change direction. Nature is nature, but Art is Nature interpreted.

Key Your Paintings Thoughtfully

Whether we are attempting to paint a high-key (lighter value) or a low-key (darker value) picture, the result will be determined by the way we use and control our values. High-key paintings will have practically no real darks, and low-key paintings will have basically no lights. High-contrast paintings will make use of most or all the values from the darkest dark to the lightest light.

Now that you know how values can be made to work for you, you won't have to stick rigidly to the way the values appear before you in the actual subject. Of

course, it is perfectly legitimate to copy them just as they are and to paint quite literally, but it might be more painterly, more satisfying and more fun to make a personal interpretation of the actual facts, to come up with a painting that is uniquely yours.

Just keep on asking yourself, Is it dark enough? Is it light enough? as you compare each value with its neighboring shape. The answers will provide the working instructions for you to use the subject material as a thought starter and not as a directive from which you must not veer.

You must adopt a planned, thoughtful approach, where a brush is not dropped haphazardly into the nearest color well, a bit of water added, and then a few indecisive scratchy strokes jabbed at the painting in the hope that they just might work. If you want to turn out consistently high quality work, *an ounce of planning is worth a ton of luck.* Keep on thinking values, values, values . . . they are worth their weight in gold.

Cafe Jazz, 14" × 10"
I saw these two musicians working in Venice. The light was very subdued and I was only aware of the big shape connecting musicians, piano and bass together. I used a restricted palette of French ultramarine, burnt sienna and a little raw umber. Whenever there are two shapes of similar value close together, don't hesitate to join them. The viewer's brain will define them.

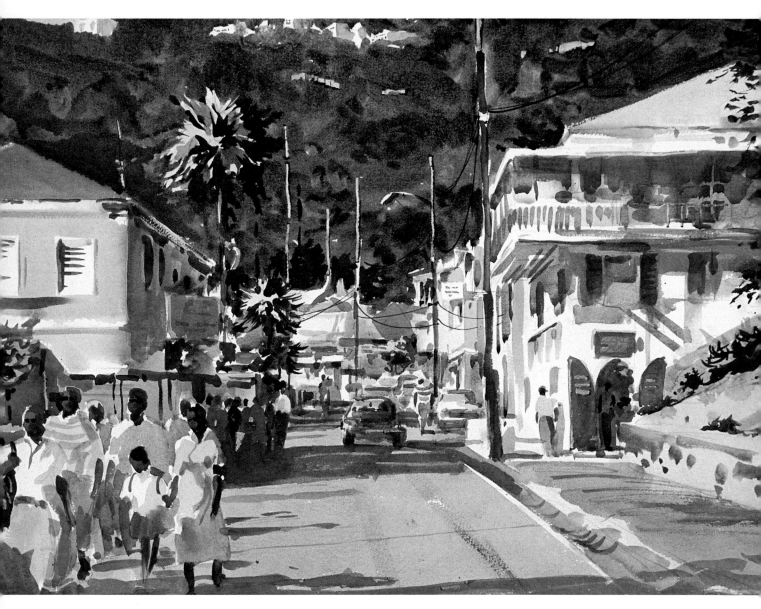

Charlotte Amalie, St. Thomas, U.S. Virgin Islands, 20″ × 30″
In this extremely colorful subject you can see how the color values are all spot on, dark against light, bright against dull. Values must be treated with your utmost concentration.

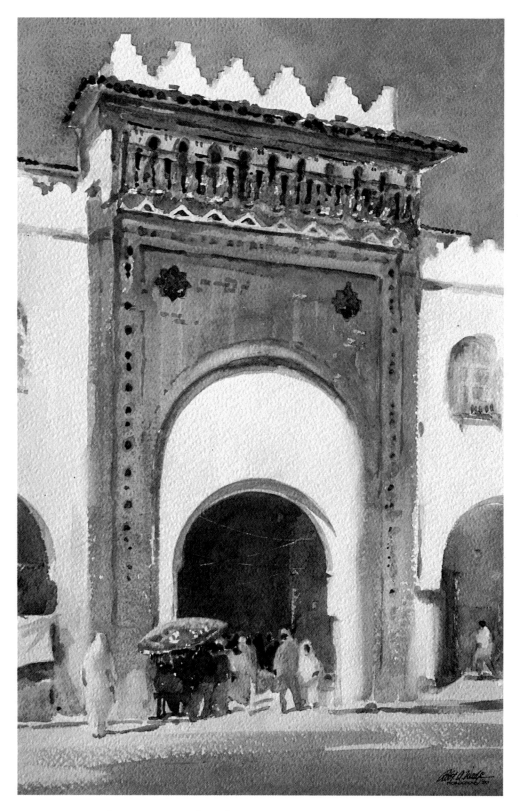

Gateway, Larache, Morocco, 20" × 15"

With this emphasis on the sky's value, the white walls almost dazzle. A warm orange wash was applied to the entire sky area and the blue glazed over it when totally dry. The very ornate facade was given just enough detail to suggest its colorful mosaics.

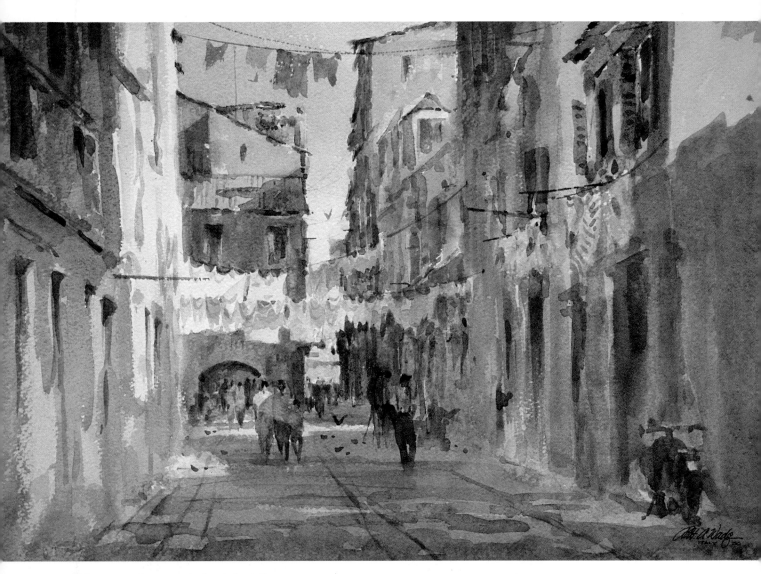

Wash Lines, Chioggia, Italy, 15″ × 20″
Here is a study of subtle values, subtle color changes, light shapes against dark, dark
against light. Notice the bottom line of washing as it gradates from left to right, with
value changes not only in the washing shapes but in the areas behind them too. See
how important the passage of light is through the painting?

Gateway to Toledo, Spain, 12" × 10"
Very careful observation of values and
color relationships kept this little sketch
full of light and air. The shadows of the
buildings, although relatively dark in
value, are kept warm and vibrant by their
color content.

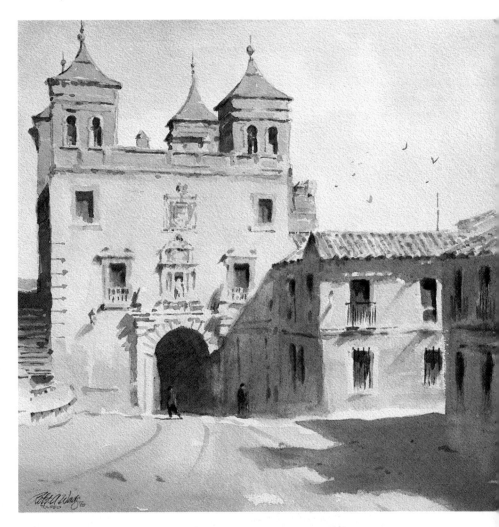

When you understand *values* and how
to achieve them in color, then *you are
in command*. You can interpret and
present a subject in any way you choose,
as I did here with three little studies of
the scene shown above.

Building Values With Layering

The traditional English method of watercolor was to build up values by continued layering of color glazes. I find I frequently have to repeat this process myself to arrive at a correct value. Here's an example:

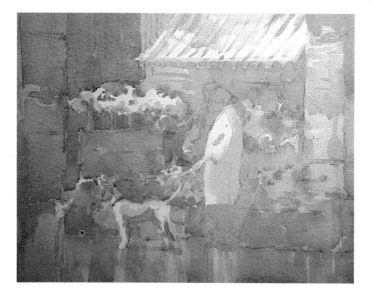

Step One

I did a careful pencil drawing of the two figures and dog, with just a broad indication of other shapes. My first wash, reserving all highlights (no masking), is an overall warm wash of cobalt blue, rose madder genuine and raw umber. More rose madder genuine is dropped into the awning and flowers while they're still damp.

Step Two

Further glazes of cobalt blue, rose madder genuine and raw umber begin to define the shapes and sculpt the values. I'm still working in the large areas without fussy detail, which will be the last thing I add.

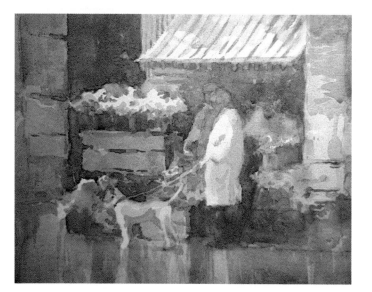

Step Three

Here I'm concentrating on more glazes, adding flesh tones and strengthening the areas behind the light shapes. If you feel that a light shape isn't as light as you want it, the area around it probably isn't dark enough to push it out.

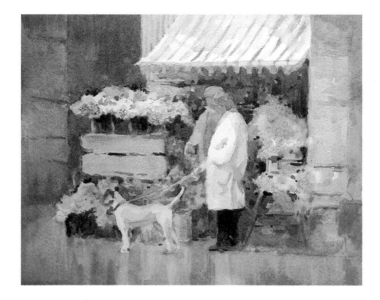

Step Four
Now I've added some darks and find I've lost my original game plan. It's too contrasty and flat—the whole thing's gone awry. Have I lost it all now?

In the Pink, 15" × 20"
What if . . . I could work on the edges, softening and refining? I could try to get a little more recession in the flower shapes and the stall keeper. I think I'll work up the contrast even more now that I've started to go that way. Last of all, when it's totally dry I could glaze over the whole picture, except for the highlights. A warm pink glaze would change the overall effect, pulling it all together and getting it to work (I hope).

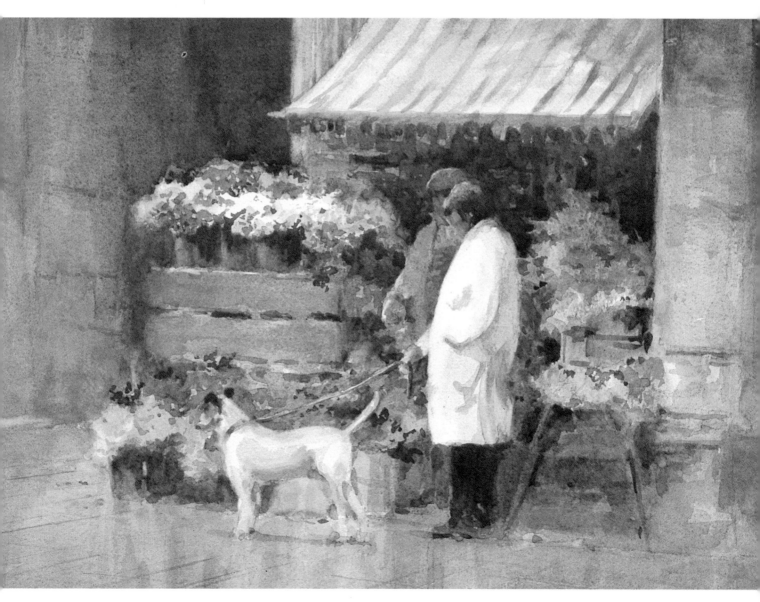

Chapter 9
Color . . .
Without Mud

A common problem, one that is not confined to students but happens to the very best of us on occasions, is muddy color. *Mud is a partial or total loss of transparency.* Generally, mud is caused by layering too many washes on top of each other, by mixing too many colors in a wash, by going back into darks too often, or by using colors like yellow ochre, Naples yellow, cerulean blue or light red. All of these colors are fairly opaque, a property they bring to whatever mixture they enter, so beware! Don't use yellow ochre unless you are very skilled in its application. Substitute raw sienna, a most useful color that will give your washes great transparency.

A Three-Color Palette

I constantly recommend that workshop students try a very restricted palette of only three transparent colors: cobalt blue, raw sienna and burnt sienna. I like to substitute light red for burnt sienna as it allows me to be just a little brighter with my color range, but I am always aware that light red has an opaque tendency. Another advantage to using a three-color palette is that, because every color mixture contains the same colors in varying proportion, you will naturally achieve color harmony in your painting.

When we start our first session on this restricted palette exercise, students usually have some degree of difficulty in coming to terms with such a small number of colors, feeling awkward and out of kilter; they are accustomed to being able to dip into their myriad colors.

However, despite their discomfort, few students produce muddy work *because they are using transparent colors.* Working in this narrow range is an extremely useful discipline; with each subsequent painting the students begin to develop an understanding and feel for the values and intermixes possible using the three-color palette.

Another good trio is thalo blue, aureolin yellow and rose madder genuine. These three colors come very close to the trichromatic scale of printing inks, which are used in color reproduction. With these pigments it's possible to produce a full value range from a very strong dark to a very transparent light.

Again, using these three colors will also teach you much about mixing grays, and as they are so transparent, they are a certain cure for the muddies.

As long as you maintain a relationship of red, yellow and blue, it is possible to vary the colors in your trio to suit the mood you want to portray in your subject. For instance, a much more somber and subdued range would be obtained from a palette of French ultramarine, burnt sienna and raw umber. A palette of cobalt blue, cadmium red and new gamboge would result in much brighter colors. Stick to the more transparent colors for good clean washes.

A mud mixture would *certainly* result from a combination of cerulean blue, yellow ochre and light red. Try all the suggested palettes, particularly this last one, as it will show you just how this undesirable mud effect comes about. Have a look at the examples I've painted for you with *my* restricted palettes, study how I've mixed them, then set to work and have a go yourself. By

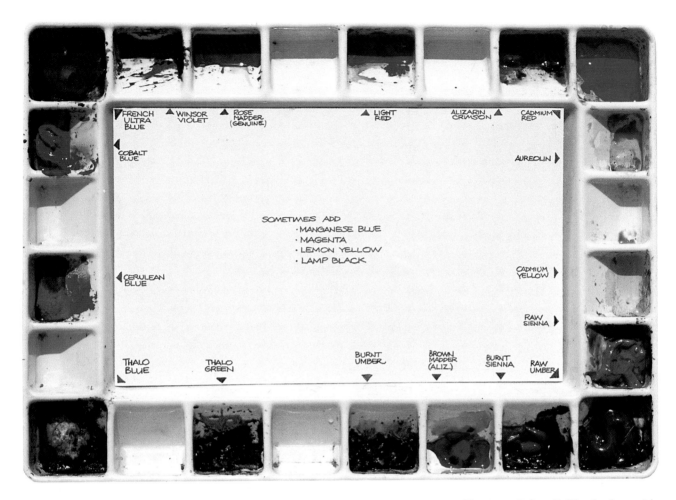

FRENCH ULTRA BLUE WINSOR VIOLET ROSE MADDER (GENUINE) LIGHT RED ALIZARIN CRIMSON CADMIUM RED

COBALT BLUE AUREOLIN

SOMETIMES ADD
· MANGANESE BLUE
· MAGENTA
· LEMON YELLOW
· LAMP BLACK

CERULEAN BLUE CADMIUM YELLOW

RAW SIENNA

THALO BLUE THALO GREEN BURNT UMBER BROWN MADDER (ALIZ.) BURNT SIENNA RAW UMBER

This is my Robert E. Wood palette with the colors labeled for your benefit.

trying them all, you'll soon get the drift of my argument and discover what a variety of moods and colors can be obtained from very basic palettes. You can go on and on, inventing new color relationships to give fresh emphasis and atmosphere to your work.

Limiting Your Palette

The demonstration on these two pages was painted with a limited palette of only three colors: raw sienna, light red and cobalt blue. I'd like you to try this triad for yourself. You'll get a good clean result as it's an easy way to avoid mud. While raw sienna and cobalt blue are both very transparent, light red is a little on the opaque side, so just make sure you use plenty of water with it.

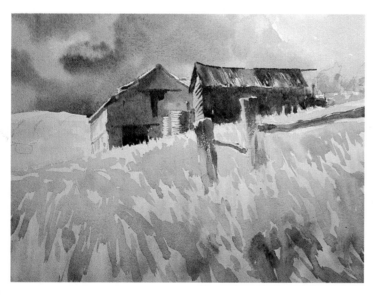

Step One
The first wash is raw sienna with a touch of light red, and stronger raw sienna is dropped into the foreground while still wet.

Step Two
A mixture of cobalt blue and light red, the sky is painted quickly and the same wash runs into the shadow side of the barn. Raw sienna is run into the bottom of the barn, picking up the light bounce from the yellow grasses. Light red and cobalt blue, mixed in various proportions, start to delineate the iron-roofed shed and posts. A stronger wash of raw sienna and light red begins to form the foreground grass shapes.

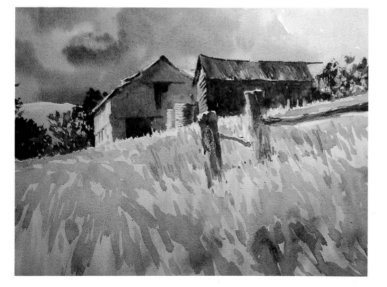

Step Three
A deeper value color for the distant trees, changing in intensity as it runs across, allows the dramatic diagonal of the hillside to emerge.

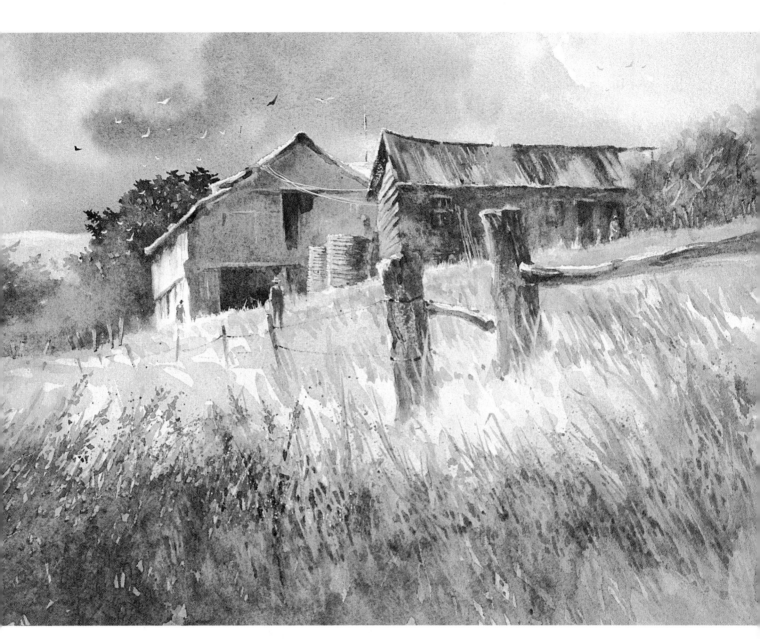

Summer Gold, Mansfield, Victoria, 15″ × 20″
The fine-tuning consisted of softening edges, adding figures, blurring the trees and detailing the foreground grasses. And there you have it—all with just three colors.

Restricted Palette Paintings

These five small watercolors all use the same three colors as the painting on the previous page: raw sienna, light red and cobalt blue. Loosely based on a South Australian miner's cottage, they just developed as I went along.

Would you believe that just three colors could provide such different moods? It all depends on how they are mixed.

Try painting a small series yourself. Each of these was a quarter sheet. I had tremendous fun doing them.

You'll be able to see from these examples that the washes are very fresh and there's no overworking.

What if . . . I discovered that the three-color palette was a certain cure for the drab, tired work I've been doing? Could I just stay with this palette forever? No. Although it provides a great exercise in controlling color and value, your work would become boring. Use it to come back to the basics every now and again.

Singapore Sampan, 15″ × 20″

What if . . . I changed to another three-color palette now? Well, let's try rose madder genuine, aureolin and thalo blue, three of the most transparent colors of all. These colors closely approximate the trichromatic printing scale and give an enormous variety of values. As you can see from the finished result, it's doubtful if another fifty colors would have improved the painting. (Actually, I did use some white opaque to get that water sparkle.)

Detail. See how the transparency of these colors allows the paper to shine through? In the reflection under the bow you can feel the sunlight filtering down into the water.

Farmhouse, West Australia, 10" × 14"
Would you believe that the same three colors have been used again here? Rose madder
genuine, aureolin and thalo blue are the base colors once more, but it's how you use
them, and in what proportions they are mixed, that determines the result.

Lake Eildon, 15" × 20"
The same three colors and a result different from the previous painting, but again all the colors are in harmony because there's some of each color contained in every mix.

Chioggia, Italy, 20″ × 30″
What if . . . I changed the clear sunny day to a soft atmospheric feeling? You can invent conditions if you feel the subject is more suited to another treatment. A limited palette of light red, French ultramarine, aureolin and Winsor violet worked very well for me in this one.

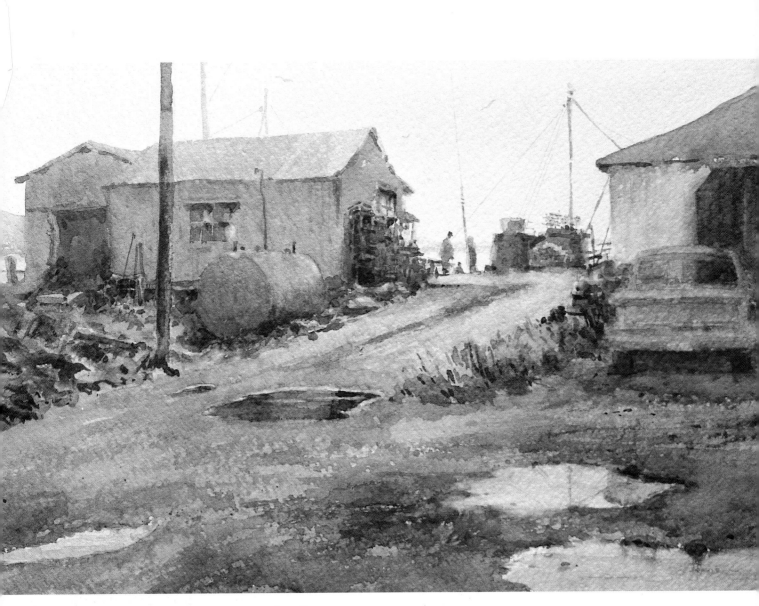

The Fish Wharf, Port Clyde, Maine, 15" × 20"
Here's an opportunity to play with textures and that high hazy light. What if . . . I used
a very rough paper and added French ultramarine to my palette instead of cobalt blue
so that I'd get some darker values? French ultramarine, burnt sienna and raw sienna
would do just fine.

Just three colors, French ultramarine, raw umber and light red, used with various values, can give totally different effects. Watch what happens to the visual impact of the boat in these three small studies. This one had the cool blue-gray sky wash continued right down over the entire surface of the paper, knocking back the boat to a *low contrast*.

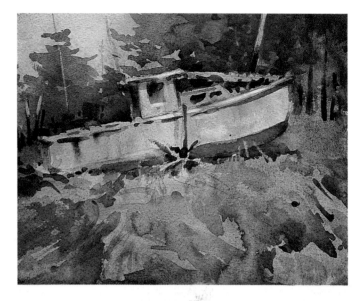

The sky wash was warmed here with raw umber and the same procedure followed, with the sky color going over everything, right down the paper. Result, the boat is now a *medium contrast*.

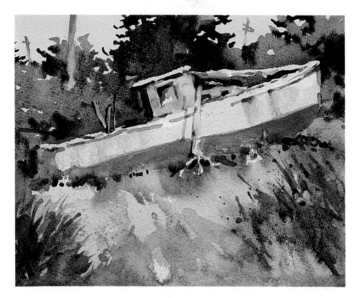

The highlight is reserved in this final sketch. Now the stark white of the paper comes through and the background trees are darker; now there's *high contrast*.

Simply by controlling color and value, you can direct your viewer's attention to the focal point of your painting.

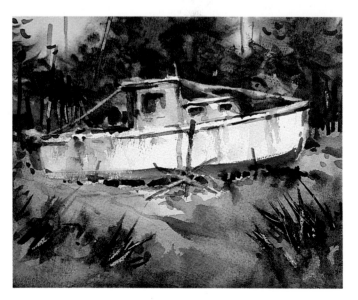

Chapter 10
Selecting a Subject

How often have you wandered aimlessly in search of a good painting spot only to find that the morning has slipped by into lunchtime or the afternoon has run out of light? It's an awful feeling to discover that a day has been frittered away without any sort of constructive blow having been struck. Here are a few productive ways to avoid the frustration of a day when you find yourself in this situation.

Plan your state of mind as carefully as you plan your painting. If you set out in the morning hoping to discover the source of a potential masterpiece, then you will almost certainly be disappointed. Very seldom in your painting life will you be confronted with a subject of such enormity that you can hardly paint for the trembling.

However, if you fix your mind on seeking out a good *value pat-*

Four small sketches in Taxco, Mexico. Such a wealth of subject matter to paint in this jewel-like Mexican village, so before starting anything too serious, a small series allows me to investigate the new environment before I commence serious painting.

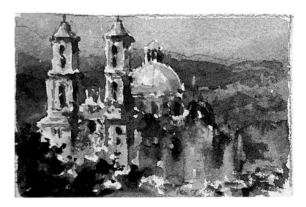

Hay-on-Wye, 8″ × 12″
I painted this small watercolor on an old piece of David Cox paper. This paper hasn't been made since the early 1950s, but I still have some sheets left. The oatmeal color of the paper gives a very mellow feeling. The pen-and-ink sketch provided the basis, to which I've added a couple of cars, changed the figures, invented the colors.

tern, this helps put your mind into an abstract mode; shapes are not given names. You won't have to think, "Wow! Look at those white boats with the red sails bobbing about on the turquoise water!" You'll start to think, "Boy! Those light shapes on the mid-dark shape make such a great pattern . . . and just look at the way the passage of light takes your eye all the way through." Once you start to think in this fashion, you will begin to find so many potential sources of subject matter that the main problem will be choosing which one you will paint first. In any case, it is *not* the subject that makes a painting great; it is the sensitivity with which the artist interprets the set of facts presented to him or her that will ultimately determine the painting's success or failure.

Keep an Open Mind

Your choice of subject is a self-service situation—nobody else can help you make your decision.

If your expectations are unrealistic right from the start, you'll find yourself shopping from only one shelf in the supermarket of subject matter. If, on the other hand, your mind is open and you are prepared to consider all the available options, then you can select from the whole store. Always make the best of whatever is offered to you in any place under any circumstances.

A few years back, I was traveling through Italy with a group of students, and I had to do a demo

A Lot of Bull, 15" × 20"
Four white faces near the center of the watercolor give meaning to this collection of abstract shapes and value patterns and make the viewer believe there's more to see than there is.

Flower Boxes, Zurich, 11" × 14"
No detail, no pretentious result, just pattern, color and value. Isn't that what picture-making involves? This was a happy little painting experience.

Houses of Stone, Crail Harbour, Scotland, 15" × 20"
Simple geometric shapes, a good value pattern, and you're home free. The calligraphy in the area of the lobster pots is the only detail, and the big shapes present the atmosphere of this quaint Scottish fishing village.

in Florence. Everyone wanted to paint the Ponte Vecchio, so I went out at six in the morning and did a bit of investigating for a suitable site. I discovered a reasonable spot behind the Uffizi Gallery, which seemed to have all the requirements: a convenient restroom, a place in the shade for us to set up our easels, no shopkeepers or policemen to annoy, bistros handy for coffee and sandwiches, and a place for our bus to park only a couple of hundred yards away.

Little did I know that the situation would be quite different when we arrived at nine. First problem: The bus was not allowed within a mile of the city so everyone had to walk in the hot summer sunshine, carrying all the usual gear with which the traveling painters overload themselves. Second problem: There was demolition work going on in the gallery, and the minute I arrived, pneumatic drills and jackhammers started up their dreadful songs of hate so that my voice could hardly be heard. Third problem: There was a constant stream of passing traffic adding noise, including those awful putt-putt motor scooters.

Trucks, cabs and cars made it very hazardous to cross the narrow road, and I was sure that one of my group would slip and fall under one of the trucks. Fourth problem: Tourists seemed to appear from thin air, and they clustered around me to watch the demo. One German guy even

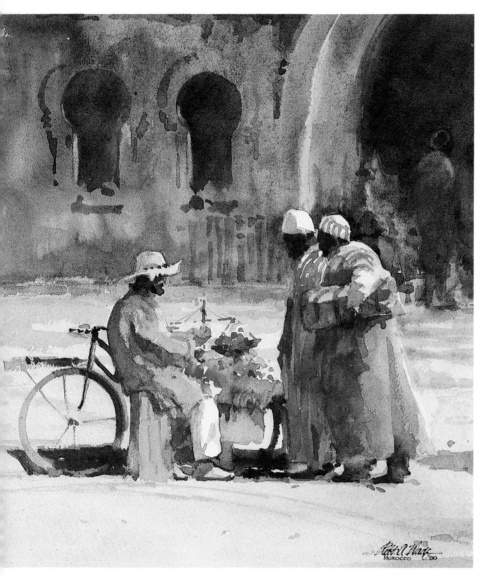

Outside the Market, Marrakesh, 12" × 12"
Working from your sketchbook allows your imagination free rein when you transpose line into color and value. I liked the little group in the lefthand corner and decided to concentrate on them. This small watercolor won a major award at the Salmagundi Club in New York.

rested a video camera on my shoulder while I was painting! I was almost ready to give up and call it a day (wouldn't you?), but I thought, "Hey, I am a pro. I just have to do my job no matter what" so I continued. The demo turned out just fine and now, in hindsight, I have a very special memory of that funny occasion.

Simple Subjects, Simple Shapes

So now I'd like to offer a few suggestions to help you get settled down to work much faster. When I have the problem of "What will I paint?" I set a time limit of, let's say, twelve minutes. At the end of that period, if I still have made no decision, then I must stop right where I am (provided it isn't in the middle of a road) and create a painting from whatever subject matter is available. Usually I discover an abstract value pattern that I had previously overlooked, maybe because I had considered the shapes by name and they were uninteresting, unappealing objects. On reconsidering their

The Blue Gate, Fez, 15" × 20"
Using my sketch, memory and imagination, I had to be careful not to become too involved in the beautiful mosaic facade. I tried to portray its feeling in the simplest way I could, because there's also much interest in the doorway shapes and the people coming and going. I liked the wispy figure I invented for the bottom righthand corner. There seem to be many wraithlike figures in Morocco—now you see them, now you don't—and this figure is typical. He also leads your eye into the picture.

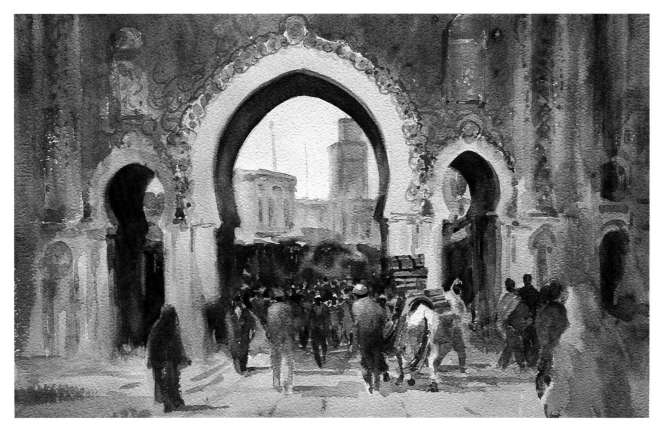

Feed the Birds, 13" × 20"
Sometimes it's fun to take a subject and
work in variations. Pigeons are universal,
and it seems that in most cities of the
world, wherever the birds are, there are
children feeding them. They make de-
lightful subjects. Note the contrast of
hard and blurred edges, the joining of
shapes, and the simplicity of the bird
rendering. It's not an illustration for an
ornithological manual; it's a portrayal of
an impression.

Hold Out Your Hands, 11" × 14"
Note the counterchange in the figure val-
ues: The light value tops are set off by
the darker value distance, and the dark
value legs set off the foreground. See
how the values of the pigeons make
them recede or advance?

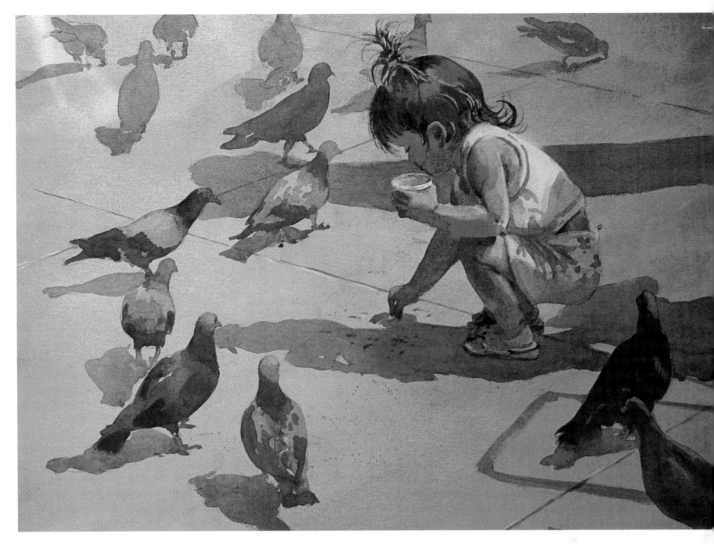

shapes and the value patterns they created, I may find a great stimulus to produce an exciting and successful painting.

Here's another handy tip. To see those less obvious patterns, use your camera as a viewer. Most people seem to own SLRs these days. It's easy to look through the viewer at the areas around you. But here's the deal: I want you to throw the lens right out of focus.

Once you have done that, when you look through the view-

finder you will be aware of all the big shapes — all the little nitpicking bits will disappear. It's like squinting and looking through your eyelashes, but it's even better because you can control the degree of out-of-focus you require. Once you have discovered an interesting area of values, just put the cover back on the camera; you don't even need to take a shot. This method gives you the chance to preview your painting pattern, rather like seeing a film clip before buying a video.

The Birdies, 18" × 24"
Here's a more finished painting. Look how important the shadows are. The birds' shadows anchor them to the ground; the little girl's shadow joins her to the pigeons; the background shadow indicates a presence outside the picture plane. There's a little more detail in the foreground birds, but in the background they are just silhouettes. I hope you can feel the roundness of the little toddler who is so oblivious to all else.

Step One

In this step-by-step demonstration, I wanted to explore further the theme of children and pigeons. I began with a detailed contour drawing of the little girl and her shadow, with the birds just indicated as shapes. A wash of rose madder genuine, raw sienna and cerulean blue was applied right across the whole background. Cerulean blue was dropped into the top area and the denim while the underwash was still damp.

Step Two

Trouble . . . the first wash was too pale and I had to glaze over it again very carefully, lifting color out from the blouse and the cup.

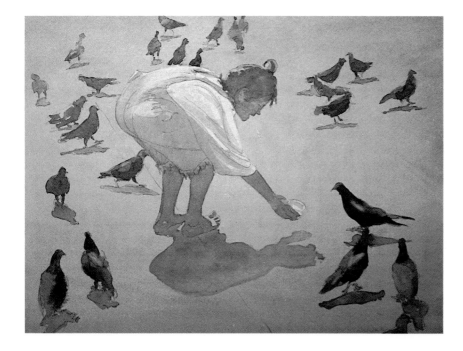

Step Three
I started the shapes of the birds, adding the flesh tone to the girl's shape, joining it to the hair shape, and joining her legs to the shadow shape.

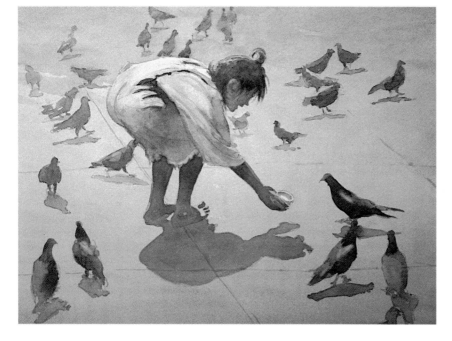

Step Four
There was a space just under the girl's face that seemed too empty so I added a couple more birds. I also worked more detail into her figure. Now it's just a matter of refining values and detail to arrive at a happy conclusion.

Too Many Choices

On other occasions you will find a locale is so exciting, so over-powering, that subjects appear at every step . . . so much to paint that it seems impossible to decide where to start. It is a dilemma, and for me it is mandatory to come to terms with myself, to sort out all the options, to restrain the urge to paint everything in sight before it disappears.

It is a good idea to take an overall view of the area before you start selecting the most suitable subjects. If I tape down a half sheet, 15 by 22 inches, and divide it into four by applying 1-inch masking tape through the centers, vertically and horizontally, I create a setup to paint little postcard-sized sketches.

Then I set to work, making simple little statements that start to give me a feeling of familiarity with the surroundings. They develop my sensitivity and observation, helping me to build a store of images and emotions from which I can begin to make decisions based on my newly acquired knowledge. It's also a fun way of working. There is no inhibiting thought like "I need this for my upcoming show, so it had better be a good one!" They also make charming little greeting cards to send to family and friends. Give this method a try. Just remember to look for the *value* patterns. The best results usually come from simple subjects and big simple shapes.

Sketchbook Subjects

Your sketchbooks are constant reference sources for painting subjects. You have already done a preselection exercise by deciding to draw a subject in the first place, and the physical act of drawing has made you simplify, giving you a great deal of knowledge on which to expand your reaction and interpretation. Even many years after you made the drawing, you will only need to hold the sketchbook in your hands for a moment to unlock a treasure box of memories. These memories will set off an avalanche of creative thoughts, bringing ideas for developing a host of different paintings.

In your sketchbook, you can also make notations about local color and other points of information you may find particularly useful in aiding your recall sometime in the future. Personally, I prefer to invent the colors and create the atmosphere and mood of my choice, unless the subject happens to be one that must be portrayed in a very truthful manner. If you don't know the pleasure of keeping sketchbooks, I urge you to start developing the habit right now.

As you now can see, there are many different ways to find a subject to paint. The vital thing is to make sure you are always on the lookout with an artist's eye, and never shut out your options.

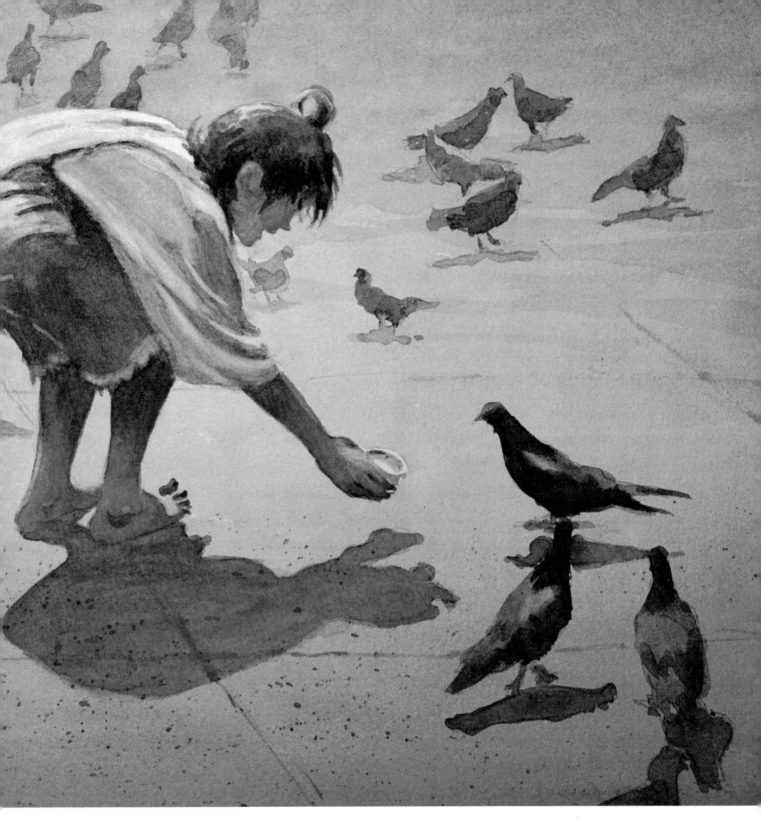

Once more I glazed a light red/raw sienna mix right over the entire painting, except for the blouse and cup, which gave a warmer feeling to the picture. I strengthened the shadow, darkened a few values and then decided to call a halt.

Chapter 11
Focus on Photography

Most artists have, at one time or another, discussed the age-old question: To photograph or not to photograph? Just mention that you employ photography for reference; suddenly eyebrows are raised and you seem to lose all credibility.

If an accountant confessed that he used calculators and computers to assist him in the efficient conduct of his business, the reaction would be quite the reverse. We know that the accountant can add, multiply and divide without those gadgets, but how much more effective he is because of their help.

The artist can draw and paint, so why is it wrong to take advantage of photography, the greatest support system we could ever have?

Using Photographs Correctly

It is tremendously important how we actually use the photographic image. If you can't manage without it, if it's the only way you know how to work, if you never get to work on-site, then you are lost, I'm afraid. It is imperative to see, feel and smell all

that's happening out there . . . the changes in light, mood, temperature, sounds, colors and odors.

How could you paint a seascape if you couldn't smell that tang of seaweed and fish in the air, if you couldn't feel the dampness of a mist clinging to the cliffs, if you couldn't hear the squawks of the gulls and the lapping of the water on the little fishing boats as they rise and fall on the gentle swell?

It's impossible to paint subjects with any degree of feeling or passion unless you have experienced that situation yourself. As an old sailor once said to me, "You don't learn about the sea by just reading pirate stories." Ain't that the truth?

Capturing Action and Lighting

Photography, however, if used intelligently can prove to be the basis for great creativity. For recording action it is simply unbeatable—athletes, animals, birds, people, cars, boats or anything in motion can be frozen so perfectly with our high-speed cameras and films.

Capturing subjects in back-lighting, which is so hard on the eyes when working on-site, becomes quite a relaxed task when using the camera. Ripples and reflections, the movement of waves and water, angry seas, fleeting clouds and changing shadows can all be arrested with the assistance of the camera. This is almost a perfect reference for the artist . . . *almost*, I repeat, because there are many adjustments to be made if you are to use that information in your painting and have it come across as a credible piece of art.

Gathering Information

Another great advantage of the camera is the speed with which it lets you gather information. I find this particularly useful when traveling in foreign countries and my time is very limited. In the time it would take me to do a sketch it's possible for me to shoot a roll or more of film.

This will provide me with thirty-six or more pieces of information to store away forever. At the last count my slide library totalled over thirty-five thousand,

This is a slide of Greta Bridge, a subject made famous in the painting of the great English watercolorist, John Sell Cotman (1782-1842).

First I did a quick on-site sketch, and later in the studio, an exploratory study for color effect. I must know where I'm going before I start the journey through a painting.

Greta Bridge, 15″ × 20″
I wanted my painting to be totally different from Cotman's in concept, color and emphasis.

What if . . . I used the photograph for reference but invented a romantic moonlit atmosphere? Here's the result.

and the slides take me back constantly to revisit countries I haven't seen for years.

My camera has also been used for the tricky little job of "shooting from the hip," a technique I have developed for places like native markets where a photographer is definitely a persona non grata. Using a camera with automatic focus and exposure, I pretend to look in the opposite direction while using the camera slung from my shoulder and dangling near my hip. I must admit that I lose a lot, but I win a lot too, often coming up with some surprising results. I've done a lot of shooting from bus windows, too. This is really high-speed stuff as you only have a second to make a decision and press the button.

Making Adjustments

The camera operates with split-second timing and accuracy at speeds of up to $\frac{1}{1000}$th of a second; the action is frozen and consequently all edges are sharp and hard. To maintain a sense of movement and form in your painting, you will need to do much thoughtful work on many of these edges. The shapes must not appear to have been cut out and pasted down on the working surface of your picture.

Try this little experiment. Stand about three to four feet from a large mirror on one of your walls. Focus your gaze on the tip of your nose reflected in the mirror. Fix your eyes rigidly on that spot and don't let them waver. Now become aware of the objects behind you that are reflected in the mirror, but *do not move your eyes*. You are conscious of all those blurred shapes and *know* that they are chairs, tables or whatever, but *only* because your brain tells you from memory what they are called.

Actually, your vision allows you to focus only on the shape at which it is looking. As other shapes move out and away from that point, their degree of softness and blurring increases.

When you paint from photos and slides you *must* adjust the edges of shapes—that is, the degree of hardness or softness—to control the viewer's eye.

Remember, *hard* edges grab the eye and capture attention. If there are some areas in your painting that seem too dominant, I'll bet you'll find that the edges are too hard. You'll have to soften them with clean water and a firm brush that you can drag gently along that offending line.

In this way we accentuate the focal point or visual path to lead the viewer's eye through the picture in the way we want it to go.

Don't be tricked by the density of shadows in photographs. They are invariably too dark and opaque; you must adjust them, using the knowledge you have acquired from your many on-site expeditions. You have observed reflected light; you've recognized influences of color; you've noticed the transparency of shadows, the difference in their color and value from morning to afternoon, and the way their shapes are governed by the objects that cast them. In other words, you have actually experienced all these conditions. Shadows in your photos should be used only as guidelines.

Prints or Slides

I never paint from photographic prints. I prefer the big images that color slides will give me, enabling me to recapture the feel of a place. I project them up as large as I can get them. I have a 12 × 8-foot wall space that I try to fill with the image I want to use as reference. I do this in daylight, which breaks down the strength of the image so that I never feel tempted to use the overly contrasty values of the film. I can also see to draw, which is always a help.

The most important thing to remember about photography is that it is only a *reference* or *source*. You must inject your feeling and response in the way you handle it, so that it is a personal reaction to the material the camera has stored for you. The way *you* employ photography will decide whether it's a windfall or a disaster.

Brumbies, Central Australia, 15" × 20"

Here's another instance of the value of a camera. Walking quietly along a creek bed, I happened upon these wild horses. I had only a second to aim and shoot before they were galloping away into the scrub. When I worked on the painting back in my cool air-conditioned studio I had to ensure that I recaptured the brilliant light, heat and feel of the Australian Outback.

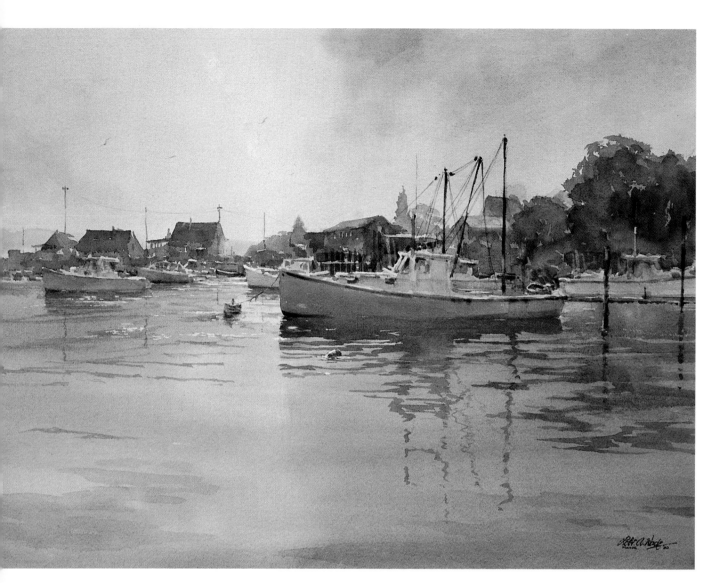

South Bristol Harbor, Maine, 20″ × 30″
As Carlton Plummer and I glided through the harbor in his boat, I shot a couple of
rolls of film, but this *contre-jour* view, stuck in my mind. When I received my pro-
cessed slides I was disappointed in the photograph, but by using my memory and
asking myself, "What if?" I finished up quite happily.

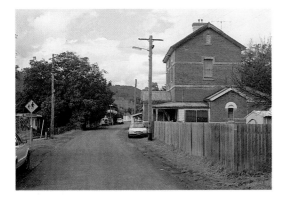

Sofala, New South Wales, Australia

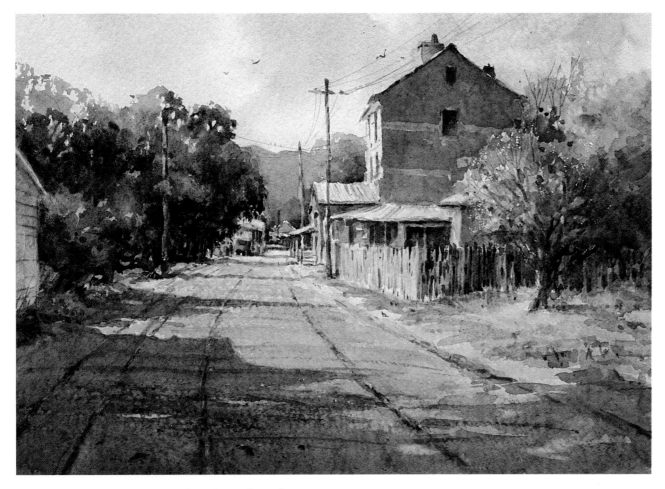

Main Street, Sofala, New South Wales, 15″ × 20″
The photo above was the starting point for this painting. I wanted to capture the quiet solitude of the little town. Visioneering enabled me to imagine the morning sun and cast long shadows across the roadway. The sky was washed in with cobalt blue and raw sienna. A warm mix of raw sienna and burnt sienna was washed in on the shadow side of the brick building and continued down the sheet right across the road area.

Working forward from the background, distant hills and buildings, I painted the shapes and foliage next, including a cast shadow across the roadway to make a connection to the other side of the painting.

Roadway textures were applied by dragging the sides of the brush across the very rough paper. Finally, a couple of puddles and some wheel tracks were added.

Ride 'Em Down, 20" × 30"
Quick impressions in the sketchbook (see pages 80-81) and $\frac{1}{1000}$-second exposures in the camera! Freezing the action with the camera was of tremendous assistance. After painting the watercolor I had to work very hard on the dusty areas around the hooves, scrubbing and sponging to remove color in order to give a suggestion of the action happening in that area.

Eye of the Wind, 20″×30″
While on a visit to Sydney, some old friends took me cruising up the Hawkesbury River in their boat. Suddenly I spotted something that looked to be straight from an old Errol Flynn movie. This wonderful vessel was in full sail about a mile ahead, so down went the throttle and we were off in hot pursuit. Out with the camera, shoot off a roll, and here's one that didn't get away. There was no opportunity for drawing and it was essential to have technical reference for all the sails, ropes, spars and so on. Boats must be correctly rendered, otherwise you can bet some expert will always be around to rubbish you if they are not.

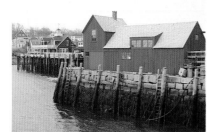

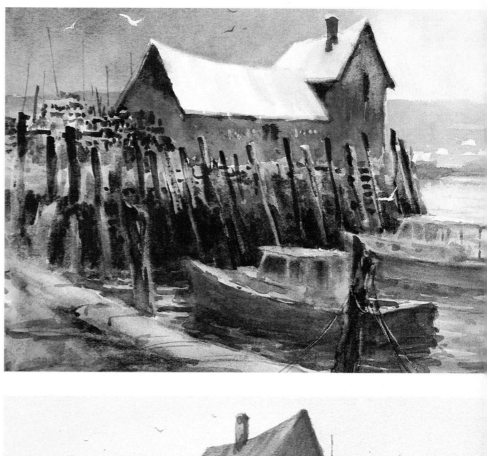

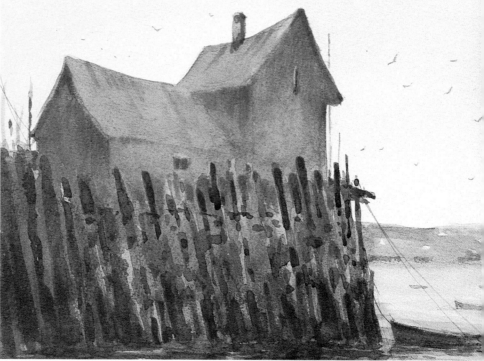

"Rockport, Massachusetts"
Photographs are *not* for copying. Use them as "kick starts" for your memory and imagination by using Perceptive Observation and Visioneering. Look at the actual photographs of Rockport, then look at the paintings. From the photographic images that represent Rockport just as it is, did I succeed in arriving at a *feeling* rather than a *fact*? What do you reckon?

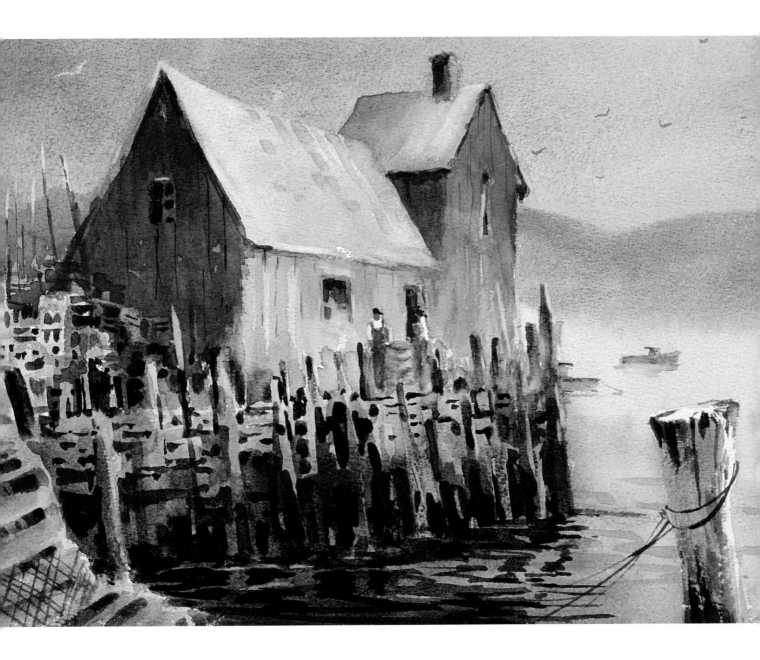

Chapter 12
Two Things to Remember

At the end of my ramblings, I have two final thoughts I'd like you to remember: 1) Don't Panic and 2) What If. . . ?

When your color dribbles or runs, when you paint right over an area you wanted to reserve as a light, when a little glob of red stays in your brush and suddenly appears in a pale blue sky wash, or when any of the other zillion things that can go wrong happens while you are producing what was to be your masterpiece . . . ***Don't Panic!***

Don't be stampeded into taking an impetuous action that may spoil the whole darned painting. Think before you act and possibly ruin it. Particularly in the beginning and early stages, don't be too quick to correct. At this time it may seem like the end of your hopes if you don't alter a problem area right away, but as the painting continues to grow, it may become quite insignificant in the final analysis. If it still is a worry, then make some changes to the offending area. Never lose sight of the painting as a whole. Don't get bogged down in small isolated areas. Keep it going all over the sheet.

What If . . . ? is a question I ask myself constantly. What if I changed the light intensity or direction? What if I changed the time of day, the season, the color, the value?

What if I were to glaze over the entire completed painting? What if I washed out the sky or the foreground? What if I added some figures? What if . . . ? This is the sort of thinking I apply to every single painting that I produce.

When I'm finally through painting, I prop it up against the wall and I start "What if-ing." Here's where the gamble begins. What are the odds of winning it or losing it totally? Even though it may well end in disaster and go straight into the garbage, that is a risk I will always take. Well, what if it does become a rip up? That is bad luck after all the hours spent on painting it, but it's only a piece of paper and now it's gone. So what? At least I had the courage to try to turn out something special, so I can hold my head high.

It might be better to wait a bit. Put the painting away in a drawer for a couple of weeks,

then take it out and ask yourself the "What ifs?" If you leave it alone for a week or two, when you look at it again it will seem quite different. You might be able to identify the problem area at first glance. When we've been working on a subject for a long time, we can suffer from the "not seeing the forest for the trees" syndrome. We become so involved with our work that it is possible to overlook a fairly obvious fault.

The ability to salvage failures is one of the marks of a good artist. Don't give up too soon when you feel that you have bombed. With "What if?" you may make some painterly decisions that result in a very innovative solution, perhaps producing a painting you would never have thought possible.

In this chapter are a few examples of how I managed to get out of corners I had painted myself into. The solutions came about because I did not panic, I did not quit. I simply persevered and created "What if?" answers to my problems.

***Toward San Giorgio Maggiore,
15″ × 20″***

This Venetian painting had nothing of
the feeling I had Visioneered . . . it didn't
even come close. "What if?" gave me a
few options, but suddenly a thought
flashed through my mind. It was an idea
that was new to me, but I could be risk-
ing total disaster. Well, why not? I re-
taped the paper to my board, sprayed
water from my bottle until the painting
surface was saturated and let it lie per-
fectly flat.

The next step was mind-blowing. Having
diluted white gouache with water until it
was about the consistency of milk, I
poured a big puddle right into the mid-
dle of the wet painting. Quickly tilting
the board almost vertically, I let all this
white color run right to the bottom, then
tipped the board the opposite way, let-
ting it run to the top. I could scarcely see
the painting through the fog of white.
What had I done? Then holding the
board quite flat, I agitated it, like a pros-
pector panning for gold, until there ap-
peared to be an even veil of the gouache
mixture over the entire surface. Then I
set it down on a level surface and waited
until it dried.

Like watching a sleeping child, I kept
peeking at the slowly drying picture. It
wasn't too bad, but I had a thought . . .
I'd just lift the veil from the tops of the
mooring posts with a tissue to give the
impression that they were protruding
from the low mist. Yes, yes! It worked,
and the result was much closer to my
initial vision. It was all soft, misty and
mysterious. How glad I was that I tried.

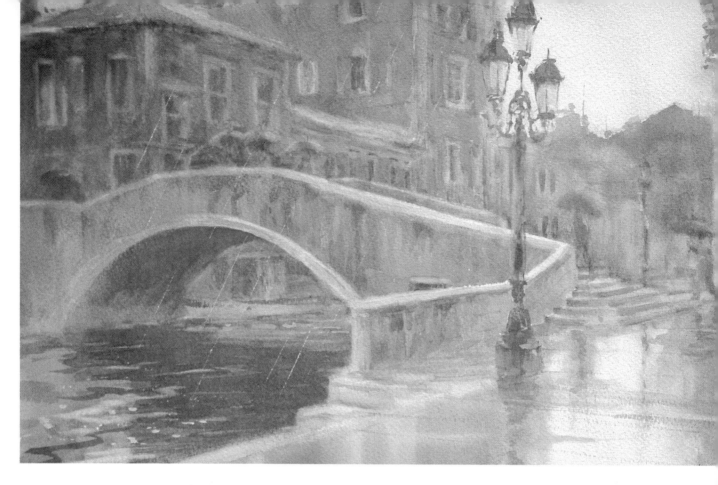

San Zanipolo Showers, 15″×20″
Some weeks later I had another Venetian
flop, so I thought I'd try the same deal
with the diluted gouache. It worked well,
but a few scratched lines to indicate rain
helped too.

The Big Fall, 20″×30″
This class demonstration had failed dismally. Back in the studio as I viewed it, "What
if?" ran through my mind. What if I painted out the foreground with gouache and
repainted with watercolor? As soon as I put the first brushstroke of white gouache
down I thought, "Wow! Looks like snow! Let's Visioneer a snowstorm!" So I just
continued with the snow idea, and it didn't look too bad.

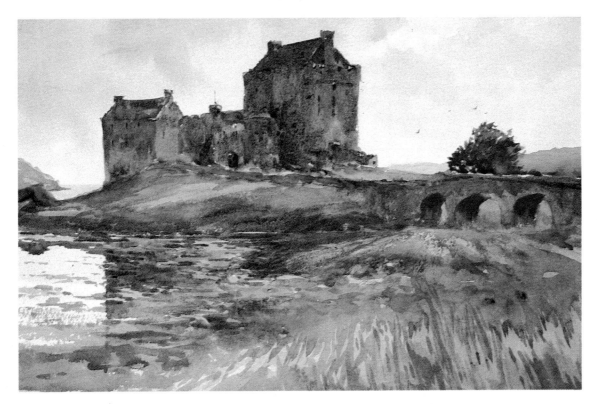

Eilean Donan, Scotland, 15" × 20"
Everything worked quite nicely except the foreground, which looked just shocking.
What if . . . I were to sponge it out and repaint?

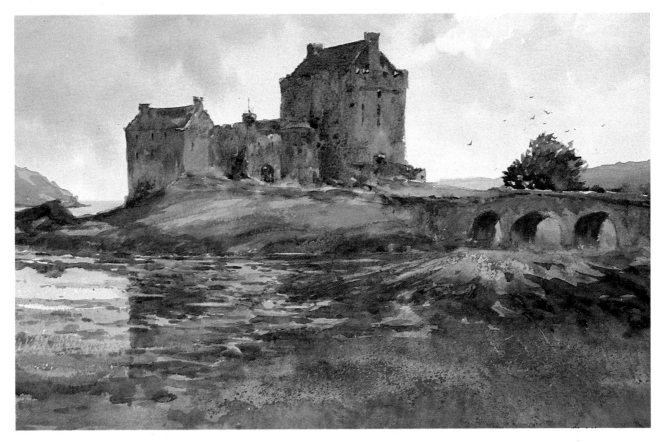

As I started to repaint the offending area, I thought, "I can give it a better feel of
Scotland even yet." So I spattered a mixture of white and purple gouache to suggest
the color of heather. How does it look now? Och Aye!

Farewell!

I'll never forget an extraordinary day in Sydney when Gerald Brommer was visiting. Jerry and I were to share the teaching of a Hewitt Workshop, Jerry doing the New Zealand content, and I the Australian. We were both a little worried that the other's teaching methods and beliefs might conflict, which would have caused total student confusion.

We met for the first time on the previous evening, when Ann and I dined with Jerry and his wife, Georgia. Jerry and I arranged to have a morning's sketching together on the next day to get to know each other better.

We set out with the best of intentions to draw the historic Rocks area. However, we soon found a view of Sydney's superb harbor and started chatting about watercolor. Some three hours later, not a single stroke had been drawn!

It was a time that we both frequently recall with tremendous pleasure. We discussed our painting thoughts and beliefs, and to our great amazement, it was like talking to ourselves in a mirror. Each of us constantly echoed the thoughts of the other. Passersby looked askance as we chortled and laughed in disbelief as the next coincidence was revealed. It was such a magical occasion, we both felt that it was one of those events that was meant to happen. The four of us have been firm friends ever since.

I am ever mindful of what a wonderful life I lead because of watercolor. I hope that in this book I have returned some of this joy by pointing out new ways for you to think, new directions for you to take. Those of you who love the medium as I do will always seek a better way. This is one of the great joys of our lives, and we will continue to search until we draw our last breath.

I wish that the English spelling of *watercolour* could be used universally, because of the *u*. If *you* are left out of a painting, the work will lack life. Put yourself in it and you have something no one else could have created.

May you continue to grow as an artist, and in the growing, may you make as many wonderful friends around the world as I have. ***Here's to watercolor!***

Index

Improve your skills, learn a new technique, with these additional books from North Light

Watercolor

Basic Watercolor Techniques, edited by Greg Albert & Rachel Wolf $14.95 (paper)

Buildings in Watercolor, by Richard S. Taylor $24.95 (paper)

The Complete Watercolor Book, by Wendon Blake $29.95

Fill Your Watercolors with Light and Color, by Roland Roycraft $28.95

How To Make Watercolor Work for You, by Frank Nofer $27.95

Jan Kunz Watercolor Techniques Workbook 1: Painting the Still Life, by Jan Kunz $12.95 (paper)

Jan Kunz Watercolor Techniques Workbook 2: Painting Children's Portraits, by Jan Kunz $12.95 (paper)

The New Spirit of Watercolor, by Mike Ward $21.95 (paper)

Painting Nature's Details in Watercolor, by Cathy Johnson $22.95 (paper)

Painting Watercolor Portraits That Glow, by Jan Kunz $27.95

Splash I, edited by Greg Albert & Rachel Wolf $29.95

Starting with Watercolor, by Rowland Hilder $12.50

Tony Couch Watercolor Techniques, by Tony Couch $14.95 (paper)

The Watercolor Fix-It Book, by Tony van Hasselt and Judi Wagner $27.95

Watercolor Impressionists, edited by Ron Ranson $45.00

The Watercolorist's Complete Guide to Color, by Tom Hill $27.95

Watercolor Painter's Solution Book, by Angela Gair $19.95 (paper)

Watercolor Painter's Pocket Palette, edited by Moira Clinch $15.95

Watercolor: Painting Smart, by Al Stine $27.95

Watercolor Tricks & Techniques, by Cathy Johnson $21.95 (paper)

Watercolor Workbook: Zoltan Szabo Paints Landscapes, by Zoltan Szabo $13.95 (paper)

Watercolor Workbook: Zoltan Szabo Paints Nature, by Zoltan Szabo $13.95 (paper)

Watercolor Workbook, by Bud Biggs & Lois Marshall $22.95 (paper)

Watercolor: You Can Do It!, by Tony Couch $29.95

Webb on Watercolor, by Frank Webb $29.95

The Wilcox Guide to the Best Watercolor Paints, by Michael Wilcox $24.95 (paper)

Mixed Media

The Artist's Complete Health & Safety Guide, by Monona Rossol $16.95 (paper)

The Artist's Guide to Using Color, by Wendon Blake $27.95

Basic Drawing Techniques, edited by Greg Albert & Rachel Wolf $14.95 (paper)

Being an Artist, by Lew Lehrman $29.95

Blue and Yellow Don't Make Green, by Michael Wilcox $24.95

Bodyworks: A Visual Guide to Drawing the Figure, by Marbury Hill Brown $10.95

Business & Legal Forms for Fine Artists, by Tad Crawford $4.95 (paper)

Capturing Light & Color with Pastel, by Doug Dawson $27.95

Colored Pencil Drawing Techniques, by Iain Hutton-Jamieson $24.95

The Complete Acrylic Painting Book, by Wendon Blake $29.95

The Complete Book of Silk Painting, by Diane Tuckman & Jan Janas $24.95

The Complete Colored Pencil Book, by Bernard Poulin $27.95

The Complete Guide to Screenprinting, by Brad Faine $24.95

Tony Couch's Keys to Successful Painting, by Tony Couch $27.95

The Creative Artist, by Nita Leland $12.50

Creative Painting with Pastel, by Carole Katchen $27.95

Drawing & Painting Animals, by Cecile Curtis $26.95

Drawing: You Can Do It, by Greg Albert $24.95

Exploring Color, by Nita Leland $24.95 (paper)

Fine Artist's Guide to Showing & Selling Your Work, by Sally Price Davis $17.95 (paper)

Getting Started in Drawing, by Wendon Blake $24.95

The Half Hour Painter, by Alwyn Crawshaw $19.95 (paper)

Handtinting Photographs, by Martin and Colbeck $29.95

How to Paint Living Portraits, by Roberta Carter Clark $28.95

How to Succeed As An Artist In Your Hometown, by Stewart P. Biehl $24.95 (paper)

Keys to Drawing, by Bert Dodson $21.95 (paper)

The North Light Illustrated Book of

Painting Techniques, by Elizabeth Tate $29.95

Oil Painting: Develop Your Natural Ability, by Charles Sovek $29.95

Oil Painting: A Direct Approach, by Joyce Pike $22.95 (paper)

Oil Painting Step by Step, by Ted Smuskiewicz $29.95

Painting Floral Still Lifes, by Joyce Pike $19.95 (paper)

Painting Flowers with Joyce Pike, by Joyce Pike $27.95

Painting Landscapes in Oils, by Mary Anna Goetz $27.95

Painting More Than the Eye Can See, by Robert Wade $29.95

Painting Seascapes in Sharp Focus, by Lin Seslar $10.50 (paper)

Painting the Beauty of Flowers with Oils, by Pat Moran $27.95

Painting the Effects of Weather, by Patricia Seligman $27.95

Painting Towns & Cities, by Michael B. Edwards $24.95

Pastel Painter's Pocket Palette, by Rosalind Cuthbert $16.95

Pastel Painting Techniques, by Guy Roddon $19.95 (paper)

The Pencil, by Paul Calle $19.95 (paper)

Perspective Without Pain, by Phil Metzger $19.95 (paper)

Photographing Your Artwork, by Russell Hart $18.95 (paper)

Putting People in Your Paintings, by J. Everett Draper $19.95 (paper)

Realistic Figure Drawing, by Joseph Sheppard $19.95 (paper)

Tonal Values: How to See Them, How to Paint Them, by Angela Gair $19.95 (paper)

To order directly from the publisher, include $3.00 postage and handling for one book, $1.00 for each additional book. Allow 30 days for delivery.

**North Light Books
1507 Dana Avenue, Cincinnati, Ohio 45207**
Credit card orders call TOLL-FREE
1-800-289-0963
Stock is limited on some titles; prices subject to change without notice.